Montréal

120th anniversary
Berlitz

- A ☛ in the text denotes a highly recommended sight
- A complete A–Z of practical information starts on p.103
- Extensive mapping on cover flaps

Berlitz Publishing Company, Inc.
Princeton Mexico City Dublin Eschborn Singapore

Original Text: Tom Brosnahan
Photography: Ted Grant
Editors: Alan Tucker, Stephen Brewer
Layout: Media Content Marketing, Inc.
Cartography: GeoSystems Global Corporation

*Although we make every effort to ensure the accuracy of all infor-
mation in this book, changes do occur. If you find an error in this
guide, please let our editors know by writing to us at Berlitz Pub-
lishing Company, 400 Alexander Park, Princeton, NJ 08540-6306.
A postcard will do.*

ISBN 2-8315-6981-8
Revised 1998 – First Printing July 1998

Printed in Italy
019/807 REV

CONTENTS

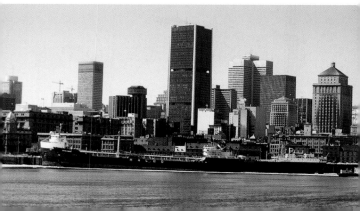

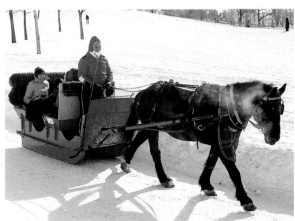

Montréal

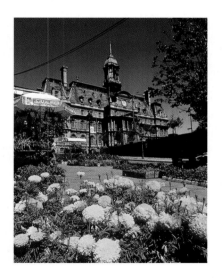

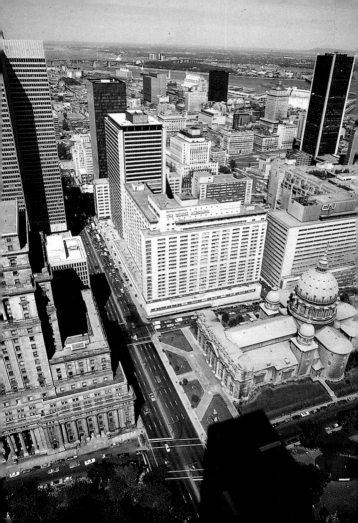

THE CITY AND ITS PEOPLE

Montréal, the Royal Mountain, is the largest French-speaking city in the world outside of Paris, yet it is located less than 80 km (50 miles) from the border of New York State. Surrounded by urban bustle, with office blocks soaring up above a grid of downtown streets, the city stands proud, with the mountain at its heart protecting its history.

At this spot lay the enchanting natural beauty shared by the Algonquin, the Mohawk, and the Iroquois. This is where the Indians established the settlement of Hochelaga visited by Jacques Cartier in 1535, and this is where you'll see the gigantic cross commemorating the time when Maisonneuve arrived to colonize the area and spread the Catholic faith among the Indians.

With its soul rooted in 400 years of history, Montréal is one of North America's most progressive and exciting cities. The Montréal Métro system speeds you along in comfort on noiseless rubber wheels to such destinations as the Olympic Park, Ile Sainte-Hèléne, and place Ville-Marie, the last a fine starting point for a jaunt through the fabulous underground city. Why not also take a boat out onto the river and marvel at one of man's greatest engineering feats—the Voie Maritime du Saint-Laurent—and return to one of the best preserved old towns on the continent, Vieux-Montréal?

If religion inspired the first European settlers in the area, furs, timber, abundant game, fertile land, and good river transport soon attracted more—making the land a rich prize for a conqueror. And so it was; in 1760 British troops had wrenched it from the French and were marching in the streets of Montréal.

Thus, the city is the child of three ancestors: its Indian natives, its French founders, and its British governors. The 200-year-old debate still goes on as to who has done the most for the city.

Of the 3 million three hundred thousand Canadians who live in Greater Montréal, about two-thirds speak French as their first language, and about a quarter were brought up speaking English. But though most Montréalers know some of each, they're not always sure whether to ask for a *chien chaud* for lunch, or a hot dog; and is it *a* hot dog or *un* hot dog? And then, where's the best place to have it, in a sidewalk café or a pub?

Adding to the variety of the place itself are immigrants from the world over, for this is a truly cosmopolitan city, where Arabs and Germans each have a weekly newspaper, Arabs and Spanish each a cultural center, and Hindus a radio program. And yet all are Montréalers; all delight in

Picturesque winter fun: ice-skating on Lac des Castors, Mont Royal.

a glass of fine cider, also known as "the wine of Québec," and in a plate of steaming *fèves au lard* (pork and beans) to fend off winter's chill.

And winter is part of the secret of Montréal. The citizens live under thick snow for several months of every year. The demanding climate brings them together, makes

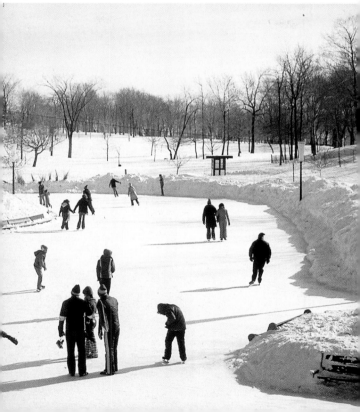

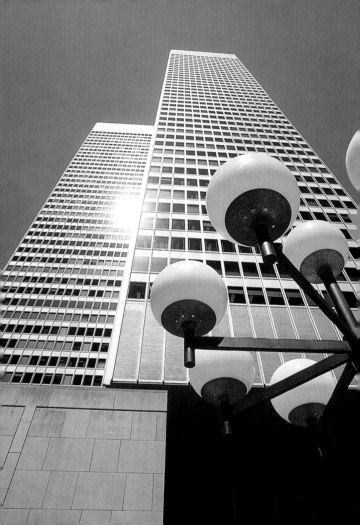

them special. In February the newspaper advertisements tempt many with invitations to warm up in sunny Florida, but most would never think of abandoning their city with so much going on: there are theatre and concerts at the place des Arts, toboggan rides down the slopes of Mont Royal, skiing and snowshoeing in the Laurentian mountains. Besides, who wants to leave town when the hockey season is at its frenetic height?

Winter is also work-time, when bankers set investment schedules, lights burn until the wee hours in university laboratories, and textile and chemical factories produce the wealth that has built Montréal. All want to be ahead of schedule when summer vacation comes, so there's time for hiking and camping, shooting the wild rivers by canoe, and fishing and swimming in the province's thousands of lakes. Montréalers head for the hills in summer, and yet the city always has a rear-guard to make sure the café tables don't go empty, and the *cafés-théâtres* put on shows that will appeal to all tastes and interests, with song, poetry, mime, dancing, and acting.

Only 250 km (150 miles) northeast of Montréal stands Québec City, the political and spiritual capital of the province, which every February unleashes its winter carnival—a madness of lights, music, parades, formal dances, and revelry. Deep down, though, Québec City is really sedate and composed, and always buttons back down after the carnival and returns to the dignified work of governing the province; but robust, forward-looking Montréal, with all the excitement of a great metropolis tempered by Gallic *joie de vivre,* is something else entirely.

The cruciform Royal Bank building looms over place Ville-Marie.

A BRIEF HISTORY

Some 22,000 years ago, peoples from Asia came and, over thousands of years, spread across North America as far as the Atlantic shore. They divided into tribes and clans, and several language groups emerged.

The Iroquois inhabited what is now the Québec region, and had settlements at Stadacona (Québec City) and Hochelaga (Montréal). They were a sedentary people and lived in "long-houses"—shelters made of bark stretched over a framework of sticks. A number of families might live in one longhouse, with only light bark partitions to separate them.

They grew small crops of corn, beans, and squash, and kept turkeys for food, but otherwise hunted and fished for

The Eskimos

The Eskimos were a later arrival to North America than the Indians, migrating from Asia about 10,000 years ago. They call themselves Inuit, which means simply "man." The word "Eskimo" comes from the Algonquin word for "raw flesh eater." The peaceable Eskimos spread to northern regions uninhabited and uncoveted by others. Hunting and fishing—and the daily task of just staying alive in a harsh environment—occupied the Eskimos for thousands of years, but they still found time to craft unique tools (snowshoes, kayaks, dogsleds) and works of art (ivory figures).

In 1975, the Inuit moved to safeguard their way of life by signing a treaty with the Government of Québec relating to the land in the area of what is now the giant James Bay hydroelectric power project. But though a few of Québec's growing Eskimo population prefer to live the hardy life of their ancestors, others have settled in towns and villages, some to work in craft or fishing cooperatives.

what they needed. Pottery, the wheel, iron, and intensive agriculture were unknown to them, but they were expert hunters and could track game with an ingenuity now lost to the world. This simple life was to be totally upset by the men in ships who came from across the sea.

Early Explorations

Francis I, king of France (1515-1547), was a determined and ambitious ruler. Stirred by the discoveries of Columbus, in 1524 he commissioned Giovanni da Verrazzano to sail across the ocean and explore the New World. Some ten years later, Jacques Cartier, who had been a member of the Verrazzano mission, set out to try to discover a northwest passage round the American continent to Asia. He came across a broad, navigable river flowing into the Gulf of Saint-Laurent, and was granted the king's permission to explore it. In 1535 he set out to sail up the mighty water-

Inuit carvings often portray local animals and human figures bundled up against the Canadian winters.

way, stopping at the Indian settlement of Stadacona and fi-
nally arriving at Hochelaga, where he was met by over
1,000 curious inhabitants. Seeing how the maple-covered
hill was the dominating characteristic of the village, Carti-
er christened the place *Mont Réal* (Mount Royal).

Almost 75 years passed before French interest in the re-
gion was fired again, and then for a wide variety of mixed
motives, ranging from economic and political to ones of
religion and prestige: it was, firstly, a rich region with an
abundance of raw material; from a strategic point of view,
a base here could be a decided advantage in case of war
against Spain, helping to prevent Spanish influence from
moving farther eastward. Furthermore, the avowed—and
often genuine—aim of many of the colonists of the time,
to spread Christianity, could be carried through. And so, in
1608, a permanent settlement was duly established in
Québec City by Samuel de Champlain. Its success led to
others, and in 1642 Paul de Chomedey, Sieur de Maison-
neuve, founded the tiny community at Mont Réal and
named it Ville-Marie in honour of the Virgin Mary. The
vulnerable little party of settlers faced destruction at any
moment, for the Iroquois nearby were not friendly. But,
sustained by their religious faith, they constructed fortifi-
cations, a chapel, and dwellings.

For half a century they suffered Iroquois raids, but de-
spite the hostile attacks, the difficult climate, and the dan-
gers of the wild forest around them, Ville-Marie grew and
prospered. By the early 1700s the French colonists (around
6,000 of them) were living in peace with the Indians, and
the town, now generally called Montréal, was growing
rapidly. The trade in furs became more and more profitable,
while farming on the rich soil produced bountiful harvests
for the people's daily needs.

The English Conquest

The French colonies were not to enjoy peace for long. At the turn of the 17th to the 18th century, the English and French were engaged in a protracted struggle in Europe, and the bitterness extended to the countries' overseas possessions as well. In North America, fighting between the two European powers hardly ever ceased, the fortunes of war favouring first one side and then the other. Finally, the issue culminated in a battle which gave the British a decisive victory in Canada.

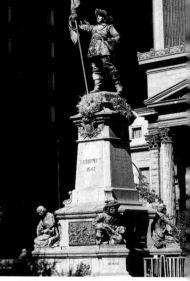

Maisonneuve, Montréal's founder, is immortalized on place d'Armes.

English forces and the colonists from Massachusetts, New York, and other American settlements joined in concerted attacks against the French, hoping to capture Québec. Some indigenous tribes joined with the French to defend the territory against threats from the south, but the English gained ground. The spearhead of the invasion was aimed at Québec City, the seat of the French Viceroy. On 13 September 1759, English forces under General James Wolfe reached a grassy, open field near the heights of Québec City's dramatic promontory, Cap Diamant, and there on the "Plains of Abraham," engaged the French troops command-

ed by Louis, Marquis de Montcalm. The ferocious fighting lasted a bare 30 minutes. At the end, the dead and dying were everywhere, among them the two generals. The French fled into the city, but the English soon overcame all resistance, and the Union Jack was raised over Québec. Within a year Montréal had fallen as well, and from then until 1982 the English monarch was Canada's head of state.

In 1775, the rebellious spirit in the American colonies was nearing the boiling point. One of the things that had aroused the anger and hostility of the colonists was the passage of the Québec Act in the British parliament in 1774. The Act was intended to provide the French Canadians with a more suitable form of government, but the English-speaking colonists of New England interpreted it as being a dangerous and arbitrary concession to Roman Catholicism.

Montréal's Mouthful

The preservation of French as Québec's major language is at the heart of Canada's most serious cultural and political problem. Relations between the English- and French-speaking communities have been marred by notable struggles, from linguistic harassment to separatist pressure to terrorism.

But at street level, an easygoing rapport between the two communities is the norm. Ease things along with a cheerful *bonjour* ("hello") and *merci* ("Thank you"). If your French peters out after that, no big problem: many French Canadians can, if necessary, speak excellent English. The more so in Montréal, a bilingual city.

As spoken here, French harks back to the 17th-century version, but with some colourful local additions and haphazard borrowing from the Americans. The local lingo is known as *joual*, an approximation of the way they pronounce the French word for horse, *cheval*.

Despite ongoing contention between federalists and separatists, some still fly the Canadian flag.

The American Continental Congress believed that French Canadians would join their Revolution, sending Benjamin Franklin to Canada to bolster support. But the king's subjects in Canada made it clear that in any conflict most of them would remain loyal to the crown. So the Continental Army under Richard Montgomery and Benedict Arnold set out to capture Montréal and Québec City. Though Montréal fell to American forces, Québec withstood the siege, and the American bid to take control of Canada was abandoned in 1776.

New People, New Wealth

Commerce in furs kept Montréal rich for almost two centuries, but towards the end of the 1700s the demand for furs changed, and the city was threatened with economic decline. Soon the Industrial Revolution was affecting much of

northern Europe, and these social upheavals were to provide Montréal with a new source of wealth: immigrants. Hoping for a better life in the New World, the newcomers brought to it their skills and their savings, using Montréal as a base for settlement. Many went on to fill the vast, fertile farmlands of Ontario and the Canadian prairies to the west, but others stayed and worked to build for the future. By the mid-1800s commerce and industry in Montréal were booming, and the flood of immigration from England, Scotland, and Ireland had made it into a predominantly English-speaking city.

With the dawning of the 20th century, the population in Montréal changed again, and French-speakers began to out-number English-speakers, though English remained domi-nant in business and government. Language became a symbol of a deeper division in society: French-speakers, who were Roman Catholic, were largely excluded from the higher ranks of society by the wealthy, Protestant English-speakers. But

The St. Lawrence Seaway

Montréal and Québec City were supported by river com-merce carried on by small wooden ships, but with the age of steam and the development of steel boats, the cities of the Saint-Laurent found that bigger ships were having problems moving up the river. In 1959 this problem was solved when Queen Elizabeth and President Eisenhower inaugurated the St. Lawrence Seaway (Voie Maritime du Saint-Laurent), a system of locks and canals enabling ocean-going vessels to go from the Atlantic up the Saint-Laurent River to the Great Lakes, a distance of almost 3,200 km (2,000 miles). The part next to Ile Sainte-Hélène is the St-Lambert Lock. At the eastern end of the Victoria Bridge, an observatory (charge for admission) allows a good view of the lock's operation, and diagrams guide the visitor through the process.

Canada was no longer simply a British colony. The Dominion of Canada had been established in 1867 to give Canadians more control over their own affairs, and by the early 1900s Canada was an independent nation in all but name. Still, English-speaking economic dominance continued, appearing to many French Canadians as a threat to their own cultural development. The language question, as a symbol of the deeper problems, became the great challenge to Canada's leaders.

As the British Empire was succeeded by the Commonwealth, the hold of England on her former colonies was weakened even more, and Canadian leaders hoped that this greater autonomy would lead to the solution of the Québec problem. To signal the country's true state of independence from Britain, the old Canadian flag modeled on the Union Jack was abandoned, and in 1965 the Maple Leaf Flag was adopted.

Firmer Ties to France

Many French Canadians still felt they did not have full opportunity for cultural and economic growth and wanted even greater autonomy: only partition of the country into two language zones, they said, could assure these opportunities. Separatists demonstrated their feelings when Queen Elizabeth and Prince Phillip visited Québec City in 1964: the royal visitors found the streets of the city deserted.

A few years later President de Gaulle of France, while on a state visit to Canada, showed sympathy with the aspirations of French Canadians and exclaimed during a speech, *"Vive le Québec libre!"* ("Long Live independent Québec!"). In late 1976 the Parti Québecois was able to form a government in Québec and gained the chance to begin putting its policies into action. The Québec National Assembly designated French as the one official language of the province, though the Canadian government recognized both French and English as official

languages. Many Québec officials encouraged the move to independence; however, in a 1980 referendum the population of Québec province rejected the idea of autonomous statehood.

Boom Town

Though the debate over language and heritage goes on, no one disputes that both French and English speakers have built their city into a major metropolis. The job was not an easy one. After World War I, when Prohibition reigned in the United States, Montréal was "wet," attracting bootleggers and other shady types. The disruption of World War II aggravated the problems of liquor and prostitution, and Montréal

A system of locks and canals now allows large vessels to travel the Saint-Laurence.

acquired a reputation as a city of sin. But in the mid-1950s, a reforming mayor, Jean Drapeau, began to "clean up." Besides rooting out corruption and crime, the Drapeau administration forged a new Montréal: slums were replaced with skyscrapers, streets and parks were improved, and the city built one of the best underground transit systems in the world. In 1967 Montréal hosted Expo '67 to show her new face to people from around the world. By the time the 1976 Olympic Games were held, Montréal had become known as one of the most progressive and exciting cities in the world.

Resonant with Maisonnueve's cross on Mont Royal, the symbol of the new Montréal is the cruiciform skyscraper that towers above place Ville-Marie. On its top, a rotary beacon scans the city each night, illuminating all that the people of Montréal have accomplished.

WHERE TO GO

Just as Maisonneuve climbed Mont Royal to survey his new settlement in 1642, jet-age visitors now do the same to get their bearings. The hill overlooks all Montréal, and from the summit the city's layout is easy to grasp. The great Saint-Laurent River flowing from the western Lac des Deux Montagnes passes the city and then continues its northeasterly journey to the Atlantic. Montréal is on the largest of several islands in the Saint-Laurent, a location well suited to commerce, recreation, and, in the old times, defense. From the hilltop lookout the low stone buildings of Old Montréal (to the east, near the port) are reminders of the earliest settlement. The city's "spine" is the range of skyscrapers and

A fountain in the place Jacques-Cartier, centrepiece of the historic heart of Vieux-Montréal.

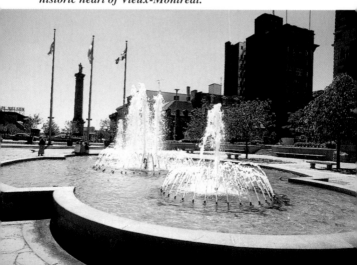

striking groups of buildings along boulevard René Lévesque. To the southeast, pont Victoria (Victoria Bridge) spans the Saint-Laurent to connect Montréal Island with the southern shore, while to the left of the bridge, 3 km (2 miles) down-river, pont Jacques-Cartier starts from Montréal Island, crossing Ile Sainte-Hèléne and the Expo '67 site before reaching the southern shore.

Viewed north from Mont Royal, the scene is residential; there stand many of the city's ethnic neighbourhoods. To the southwest, the smaller hill of Westmount can be seen surrounded by huge old houses owned by Montréal's wealthy families. The northwest part of the island is covered with residential and industrial sections stretching all the way across to the neighbouring island of Laval. If the weather is very clear, you can see the low range of the Laurentians to the north. The Green Mountains of Vermont may also be visible if you look in the opposite direction, to the south.

VIEUX-MONTREAL (Old Montréal)

Here's where it all began. Take the Métro to the Champ de Mars station and follow the signs to Vieux-Montréal. Make your way up the hill to the grand **Hôtel de Ville** (City Hall), built in a 19th-century revival of French Renaissance style and finished in 1877. To the west of the Hôtel de Ville is place Jacques-Cartier, starting point for a stroll through the historic heart of the city. The column in the square dedicated to Lord Horatio Nelson, the heroic British Admiral of the Battle of Trafalgar, is the city's oldest monument (1809).

Old Montréal's French heritage springs to life in the quaint stone buildings in and around **place Jacques-Cartier.** The French style was well adapted to the rigorous life of the frontier: high, steep-sloping roofs kept snow and ice from

accumulating and damaging the structure with their weight; the stone walls and small double-glazed and shuttered windows offered sturdy protection against the harshness of the winter weather.

Northeast of place Jacques-Cartier on rue Notre-Dame, near the Hôtel de Ville, is the stately **Château de Ramezay,** home of Claude de Ramezay, the French king's viceroy in the city from 1703 to 1724. He had such good taste in houses that this one, which he had built as his residence in 1705, was used by the British when they became masters of Québec. Later, when the American generals Montgomery and Arnold took the city from the British in 1775 (see page 17), they just appropriated the château for themselves as well. Benjamin Franklin stayed here when he was sent by the Continental Congress to cajole Montréalers into supporting the American cause, but he failed; so did the American invasion, and the château was soon again occupied by subjects of the British king. Today Château de Ramezay is a museum displaying souvenirs of the history of Québec in the 18th century. The building's interior was renovated and modernized as recently as 1977, but the vaults dating from 1705 are original and furnished in the style of a colonial kitchen. The château is open Tuesday through Sunday from 11:00 A.M. to 4:30 P.M.

> **Six question words:**
> What? – *Quoi* (kwah),
> Where? – *Où* (oo),
> When? – *Quand* (kahng),
> Who? – *Qui* (kee),
> Which? – *Lequel/Laquelle* (lerkehl/lahkehl),
> How? – *Comment* (kommahng)

Blooming marigolds line the place Jacques-Cartier, offsetting the formality of Hôtel de Ville.

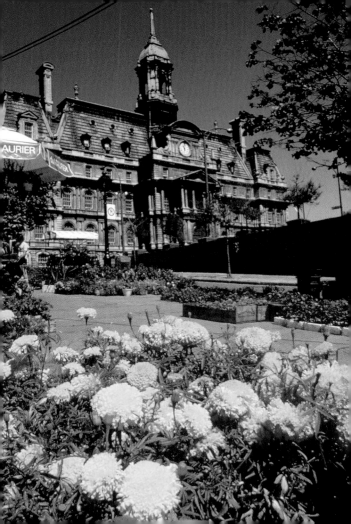

At the northwestern corner of place Jacques-Cartier is the former site of the **Silver Dollar Saloon,** famed in the early 19th century because of the small fortune—up to 350 U.S. silver dollars—inlaid by the owner in the tavern floor. Practically next door at Number 152 is a tall, thin store building dating from the end of the 1700s called La Sauvegarde; although it was renovated at the turn of this century, its façade is interesting.

Facing place Jacques-Cartier are three notable houses, beautifully restored and now used as restaurants. The **maison Vandelac,** to the left of the Hôtel Nelson, adds its antique charm to the activities in the square. The **maison Del Vecchio** (1807) is on the square's southern corner, and the **maison Cartier** on the eastern corner.

At the bottom of the square near these houses, turn left onto rue Saint-Paul. The long façade of **Marché Bonsecours**

Marguerite Bourgeois

In 1653, Marguerite Bourgeois decided to devote her life to educating the youth of the growing colony in Montréal and said good-bye forever to her native town of Troyes, in Champagne. Sailing for New France with the encouragement of Maisonneuve, she came with three marriageable girls "of good character" to teach in her school and establish wholesome households in the colony. The experiment worked, and later she encouraged other young women to come to Montréal. With this enterprising public-relations effort, early Montréal took on some of the refinements of civilization, softening the harsh frontier-town atmosphere. Marguerite Bourgeois and her followers later formed an order of nuns, the Congregation of Notre-Dame, to continue teaching in the colony. Three hundred years after she landed in Montréal, Marguerite Bourgeois was canonized a saint.

The graceful façade of Marche Bonsecours stretches down rue Saint-Paul.

graces the right-hand side of the street. The present building, dating from the middle of the 19th century, was built as a city hall, with offices, a ceremonial hall, and market stalls. Now, it accommodates civic departments, including Montréal's housing and planning department.

Past the Marché Bonsecours is the church of **Notre-Dame-de-Bonsecours** (the "Sailors' Church"). In 1657 a chapel was built here for Marguerite Bourgeois, the colony's first schoolteacher, but it was later destroyed by fire. The present church was finished in 1771, and various modifications and additions have altered its appearance since then. Inside, the wide, low arch of the ceiling is curiously painted in *trompe l'œil* to look like the ceiling of a lofty Gothic cathedral. Very

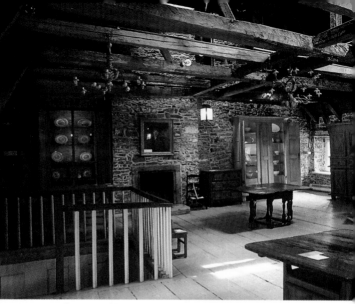

near the port, Notre-Dame-de-Bonsecours was a favourite place of devotion for sailors, who donated model ships they had carved during long sea voyages. These models now hang from the ceiling as symbolic "lamps," fitted with tiny electric bulbs. The church is especially pretty in the morning on a bright day, as sunlight streams through the stained-glass windows on the south wall. A small museum here features dioramas depicting the life and work of Marguerite Bourgeois in Vieux-Montréal; the church tower is open to visitors, and offers a sweeping view of old town and the former harbour.

Vieux-Montréal is filled with history. The best way to enter the world of the past is to explore a house of the past. The **Calvet House** (1725), across rue Saint-Paul from Notre-

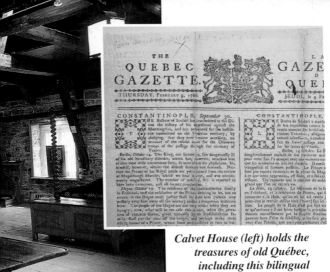

Calvet House (left) holds the treasures of old Québec, including this bilingual Gazette (above) from 1786.

Dame-de-Bonsecours church, has been restored and fitted with pieces from the Montréal Museum of Fine Arts' collection of antique Québecois furniture. Wide, rough-hewn floorboards and casement windows to keep out the icy winter air contrast strangely with elegant furniture. Period paintings, a small hooked rug, lanterns, clocks, and china complete the picture of upper-class life in the early French colony.

The wooden beams above the top-floor bedroom of the house show how the roofs were designed to withstand the blizzards of a Montréal winter. Take a look at the framed copy of *The Québec Gazette* on the ground floor, dating from 1786 and printed in both English and French—an early effort at bilingualism.

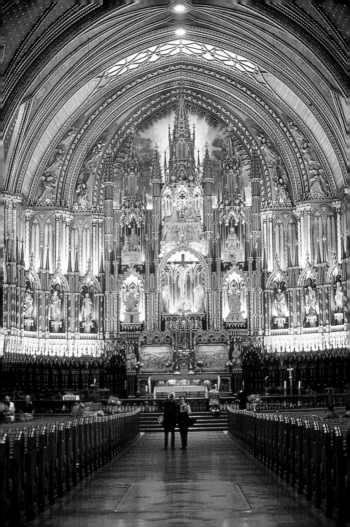

Southwest of place Jacques-Cartier, six blocks along rue Notre-Dame, is the **place d'Armes,** with its monument to Montréal's founder, Maisonneuve. **L' église Notre-Dame** on the square, a center of Roman-Catholic worship in the city, is a must for any visitor to Montréal. Designed by an Irishman, James O'Donnell, and redecorated by Victor Bourgeau in the 1870s, the opulent interior appeals to the Québecer's love of French tradition, while the lavish use of native carved wood figures and designs makes the church familiar and uniquely Québecois. Begun in 1829 and completed in the 1840s, Notre-Dame is not the city's oldest church, but it is certainly the most beloved. The great bell is one of the largest on earth; called Le Gros Bourdon, it weighs 12 tons.

Annexed to the main church, a simpler but still impressive **Chapelle du Sacré-Coeur** (Chapel of the Sacred Heart) is located behind the main altar. The chapel was destroyed by fire in 1978, but has been reconstructed. The decoration of the vast ceiling, which was previously quite a feature, has been redone partially as before, partially in a contemporary style. Also behind the main altar, next to the chapel, is a small museum devoted to souvenirs and memorabilia of Roman Catholicism in Montréal. Among other items displayed are two fascinating **paintings** by Pierre-Adolphe Arthur Guindon (1864-1923). Guindon, a Sulpician monk interested in the Iroquois culture, was an accomplished painter; his pictures *The Singing Monster* and *The Spirit of the Lac des Deux Montagnes* approach surrealism. Another treasure in the museum's collection is a gorgeous antependium embroidered by Jeanne Le Ber (1695-1724) in gold, silver, and brightly coloured beads.

The architect who designed L'eglise Notre-Dame actually converted while in the process of building it.

Youville Stables were never stables: once offices and ware-houses, this is now a fashionable residential address.

Beside L'église Notre-Dame in the place d'Armes is the group of stone buildings (said to be the oldest in Montréal) housing the **Seminary of Saint-Sulpice.** The curious clock on the façade (1710) was driven by a wooden movement until the turn of the century.

Facing the church from across the place d'Armes, the domed building is the **Banque de Montréal.** The city's oldest, it's an impressive structure of marble, granite, and brass. In the entrance hall, shiny black pillars frame a statue of *Patria* dedicated to the "Men Who Fell in the Great War, 1914–1918." The grand hall of the Exchange Room, behind the statue, is worth a look because of its size and very substantial furnishings. Off the entrance hall is a small banking

museum featuring a teller's window modeled on that of the first bank (1817), and various other mementoes.

Named after the lady who founded Montréal's order of Les Soeurs Grises (The Gray Nuns), **place d'Youville** is very near the spot where tradition has it Maisonneuve built the little fort he called Ville-Marie. A fanciful little brick building that was Montréal's old fire station houses the **Centre d'Histoire de Montréal,** presenting a documentary history of the city (see page 74).

Just next door is the entrance to the **Ecuries d'Youville** *(Youville Stables).* The gray stone buildings, identified by the bull's-eye windows under the eaves, enclose a fine courtyard very much in keeping with the spirit of Vieux-Montréal, even though the buildings only date from the

The cubist Habitat complex offers a completely different living environment.

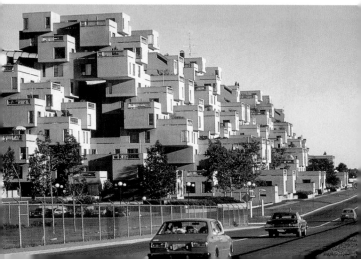

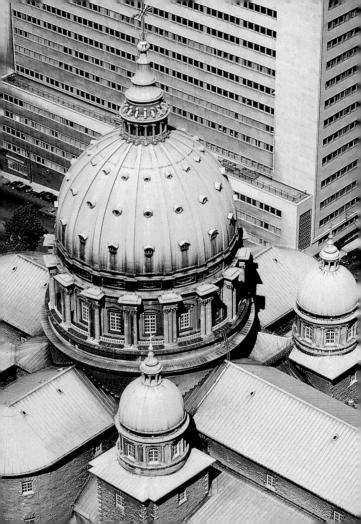

early 1800s. They were not really designed as stables, but rather as factories, warehouses, and offices; one section was used by the Gray Nuns as a hospital. Restoration work undertaken by a group of Montréal businessmen in the 1970s made Youville Stables one of the most attractive addresses in town, and several firms have rented office space here. In summer, part of the courtyard serves as a lively outdoor restaurant and open-air theatre.

Walk northeast through the square from the Ecuries d'Youville and look down the rue du Port on the right, for a view of the architecturally advanced dwelling complex called **Habitat,** a collection of modular living spaces, breezeways, and outdoor areas, which gives the impression of a veritable "airborne village." At the eastern corner of the place d'Youville, where the square meets the rue de la Commune, is a spot called Pointe-à-Calliére, once a point of land extending out into the water at the end of which was Maisonneuve's first fort. Across the street in the small place Royale an obelisk commemorates the city's foundation in 1642.

A WALK DOWNTOWN

Near the foot of Mont Royal, downtown Montréal hums with activity. Certain landmarks tower above the urban jumble: the cruciform office tower of the place Ville-Marie, Montréal's earliest effort at urban renewal, and the Château Champlain hotel, which is variously described as either a "wedding cake" or a "cheese grater" depending on one's taste. The Canadian Imperial Bank of Commerce, yet another skyscraper, has an observatory at the top.

Christ Church Cathedral is a haven for the spirit
surrounded by a sea of commerce.

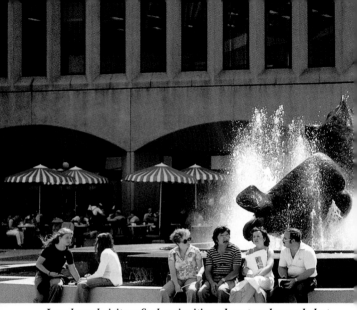

Locals and visitors find an inviting place to relax and chat in the place Ville-Marie.

The axis of the city's downtown area, boulevard René Lévesque bisects **Dorchester Square,** a fine starting-place for exploring the heart of Montréal on foot. Coach tours also leave from here. Or hire a horse-drawn *calèche* (carriage); they wait on Dorchester Square.

In warm weather this plot of greenery serves as an open-air art gallery, splashed with the canvases of young Canadian painters displayed for the benefit of the passer-by. The bright colours of the paintings and of the flower-vendors' wagons contrast with the dark tones of the square's

sober statues to Robert Burns, early Canadian prime ministers Laurier and MacDonald, and to Canadian soldiers who fell in the Boer War; but Henry Moore's *Reclining Nude* lends a lighter touch.

Today the square is surrounded by towering commercial palaces: the Sun Life Building, the Dominion Building, and the Canadian Imperial Bank of Commerce. Walk northeast along the boulevard and you pass in front of the Roman-Catholic cathedral of Montréal, named **Marie Reine-du-Monde.** Dedicated in 1870, it's an authentic copy, though half the size, of St. Peter's in Rome.

Just past the church is one of Montréal's outstanding hotels, the Queen Elizabeth *(Le Reine Elizabeth),* which towers yet higher above the Central Station *(Gare Centrale).* Across from the hotel's main entrance is **place Ville-Marie,** a complex of office buildings of which the most impressive is the Royal Bank's cross-shaped tower, designed by I.M. Pei. The Québec Government has a Tourist Information Office at the northern corner of place Ville-Marie, near the intersection of University and Cathcart streets.

Go northwest along University Street to rue Sainte-Catherine and **Christ Church Cathedral.** This very authentic-looking English Gothic church, actually constructed in the 1850s, is the seat of the Bishop of Montréal.

Rue Sainte-Catherine is Montréal's main shopping thoroughfare; crowds flock up and down it winter and summer alike with people out to buy or just to look. If you head southwest along the street from Christ Church Cathedral you'll pass the city's large established department stores as well as movie theatres, travel agencies, delicatessens, and cafeterias.

Nine blocks west from Christ Church along Sainte-Catherine, you'll come across the intersection with **Crescent Street** which, with neighbouring Mountain and Bishop

streets, is one of the centers of Montréal's boutique and bistro areas. A dozen city blocks here were saved from urban renewal, and the Victorian stone row-houses have been preserved, refurbished, painted brightly, and converted into exclusive or off-beat shops, chic bars, and trendy restaurants.

Walk up Crescent to **rue Sherbrooke,** another major thoroughfare. Here, you are in the middle of Sherbrooke's antiques-shop section. Mingled with the elegant antiques shops are others displaying costly goods such as Oriental carpets, silver, and furs. Very near the intersection of Crescent and Sherbrooke is Montréal's **Musée des Beaux-Arts** (*Museum of Fine Arts),* a popular place for spending a few hours (see page 72).

Continuing on a zigzag course through downtown, head northeast along Sherbrooke for six blocks to reach the

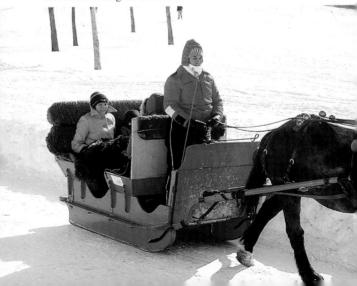

main gates of **McGill University,** one of Montréal's four great universities (McGill and Concordia are anglophone, the Université de Montréal and the Université du Québec à Montréal are francophone). Chartered by the king in 1821, McGill did not really begin to take its present shape until the 1860s. Its founder, a Scot named James McGill, had come to Canada to make his fortune in the fur trade; though he never saw the university's opening, the funds and land were his bequest to the city. Widely acclaimed as an institution with high standards, student enrollment today is about 15,000.

MOUNT ROYAL PARK (Parc du Mont-Royal) 👉

Maisonneuve's original wooden cross has been replaced by a larger steel cross wired for lighting, but the hill itself re-

tains much of the natural beauty it must have had during colonial times, and it continues to be a haven of peace in the middle of the bustling city.

A footpath and stairs, open summer and winter, lead from the end of Peel Street through the park to the summit of Mont Royal. Good for a more gradual climb on foot or by car, the "Remembrance Road" on

Roll back the years on a sleigh ride through Parc du Mont Royal.

the northwest side of the park winds gradually up the hillside as well.

Funded by the city, Parc du Mont-Royal was designed by Frederick Law Olmstead, who also planned New York's Central Park and Boston's Fenway Park. Since the late 19th century its roads, paths, picnic areas, lookouts, pond, and other facilities have made it one of Montréal's favourite green spaces. **Lac des Castors** (*Beaver Lake*), halfway up the hillside, is the place for ice-skating and sledding in winter, and for picnics or quiet strolls along the shore in summer. And at the top of the hill, the terrace of the Chalet Lookout offers a **panoramic view** of the city. The Chalet itself is a rather grand stone and Nordic-timbered hall bedecked inside with the flags of many nations. The carved wooden squirrels which are part of the interior archwork seem almost as real as the tame ones that eat tidbits from your hand.

> **Signs:**
> *entrée* – entrance
> *sortie* – exit
> *arrivée* – arrival
> *départ* – departure

There are many ways to explore Parc du Mont-Royal, including the *calèche* (carriage). In winter snow, the drivers harness their horses to sleighs and wait near Lac des Castors. Or try jogging up the hill, like the more athletic Montréalers, who do this in all seasons. Winter also brings out the cross-country skiers and snowshoe owners who use the well-marked trails winding through the park.

MONTREAL'S "COMPLEXES"

Montréal's place des Arts (Métro: *Place des Arts*) was planned and started in the 1950s, though the concert hall, **Salle Wilfrid-Pelletier,** didn't open until 1963. Contemporary in design, the façade of the concert hall nevertheless follows harmonious classic lines. Tapestries and sculptures by

The underground place Bonaventure complex includes a hotel, restaurants, two movie theaters, and a nightclub.

Canadian artists decorate the foyer, including a soapstone sculpture by the Eskimo artist Innukpuk.

Something is always happening on the place des Arts, a hub of cultural activities. A monthly calendar of events, issued free, is available in tourist offices and hotels.

As part of the place des Arts, **Complexe Desjardins** is one of the city's most exciting examples of modern architecture—an under-and-over complex built by La Haye-Ouellet and Blouin in 1976 (across Sainte-Catherine from the concert hall). Enter the grand glass portals on Sainte-Catherine and you find a self-contained multilevel environment of terraces,

Montréal's Métro is the city's pride: efficient, clean, and quiet, it ties the whole city together.

balconies, mezzanines, and a sunken plaza covering 0.4 hectares (1 acre). Light and airy, with small waterfalls, fountains, trees, and garden plots, the central area provides a harmonious environment.

The complex's design is based on several geometric shapes appearing frequently in patterns, both in the grand conception of the buildings and in details of decor. The colours reflect Montréal's cityscape, with Montréal's silvery gray predominating, set off here and there by flashes of bright colour. Texture is also handled very successfully—the concrete, metal, and glass of the modern city softened by benches and railings of natural wood. Perhaps the happiest triumph in the design is that the complex, no sterile showpiece, is used by everyone—

from shoppers and out-of-town vis

joining business and government o

to the plaza for lunch or a coffee br

From the Complexe Desjardin

ground to the **Complexe Guy-Favr**

Montréal's Chinatown, this comple

government administrative services,

ference centers, and apartments. Th

sion church and adjoining school

renovated and incorporated into this

Continuing south, you'll see a gigantic green typewriter, which is in fact the **Palais des Congrès.** The whole façade is an enormous glass wall that illuminates the entrance hall and access to the circulation areas. This building can accommodate up to 5,800 people in 31 conference rooms, and the kitchen is equipped to serve gourmet banquets for 4,800 guests.

THE CITY UNDERGROUND

They say it all began by accident, when someone suggested that there should be a few shops under the place Ville-Marie complex that was then being built. The idea was blown up into an urban underground connecting major centers by walkways, themselves joined to Métro stations, so that during the long, cold, wet winter one could work, shop, go to a movie, or have dinner without having to brave the elements. It's quite a curious feeling to walk out of your hotel in bad weather without overcoat, raincoat, or boots for a night on the town!

Start your wanderings through the city underground on place Ville-Marie. Occupying part of the complex are the Queen Elizabeth Hotel and the Central Station, along with a **Société des Alcools** *(Québec Liquor Corporation)* store, many elegant shops, several restaurants, discotheques, and taverns. There is no Métro station on place Ville-Marie, but

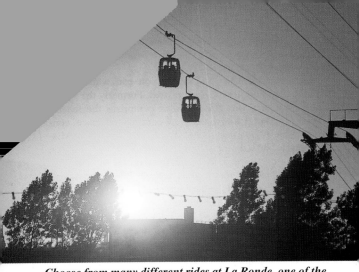

Choose from many different rides at La Ronde, one of the most happy-go-lucky places in Montréal.

you can get to one without going outside. Follow the signs to the Central Station, walk through the station hall, and then continue to place Bonaventure. Take the escalator down to Le Passage, a subterranean passageway to place Bonaventure.

The **place Bonaventure** complex is a major part of the city underground. The Bonaventure Hilton International, a favourite with convention groups, has an attractive roof-top swimming pool. In a tiny court furnished with trees and benches, the pool is surrounded by the hotel building but is open to the sky all year round. In winter the pool is heated and brightly lit from underwater. Steam rises in great clouds as swimmers luxuriate in the warmth of the water. A tunnel connecting the outdoor pool in the court with an interior one

next to the changing rooms permits swimmers to glide from indoors to outdoors without ever leaving the water.

Other entertainment on place Bonaventure includes two movie theatres and several restaurants, as well as a nightclub.

Follow the Métro signs to the Bonaventure station, and then (without entering the Métro) to **Windsor Station** (1886), designed by Bruce Price, the architect responsible for the famous Château-Frontenac in Québec City. A showing of works by Canadian painters will usually be displayed in an impromptu gallery on the main concourse. Walk back toward the Bonaventure Métro and follow signs to the place du Canada, site of the impressive **Le Mariott Château Champlain Hotel,** with its movie house, disco, and cocktail lounge.

> Unlike in English, all syllables in French have more or less the same degree of stress (loudness).

In another corner of the city underground is **The Eaton Center,** off rue Ste-Catherine, near the McGill Métro station. Opened in 1990, it's the largest shopping center in downtown Montréal, with boutiques, restaurants, and movie theatres.

ILE SAINTE-HELENE (St. Helen's Island)

One of the city's most popular summer attractions is on the Ile Sainte-Hélène (Métro: *Ile Sainte-Hôtel*). The site of Montréal's 1967 world fair now serves as a multifunctional park. Swimming pools and picnic tables are attractions through the summer; skiing and snowshoeing take over in the winter. **La Ronde,** one of the world's best amusement parks, is a highlight of the island. It's often compared to Copenhagen's famous Tivoli Gardens because of its myriad entertainments and its happy-go-lucky feeling. You can choose from among dozens of different rides, including the highest dual-track roller-coast-

The Jardin Botanique is the perfect place for plant-enthusiasts and quiet-seekers to take a stroll.

er in the world. "Chnougui-Ville," a children's model village, features attendants dressed as fairytale characters; a nautical staging post has space for 100 boats. An aquarium is open year-round, and every June (on Saturdays) and July (on Sundays) an **international festival of fireworks** is held on the island. The Théâtre de la Poudrière puts on plays and concerts throughout the year, and nearby is the famed Hélène-de-Champlain restaurant.

The park is open from mid-May to the end of May weekends only 10:00 A.M. to 9:00 P.M., then daily until late August from 11:00 A.M. to 11:00 P.M. Sunday through Thursday, and until midnight on Friday and Saturday.

While visiting the island, stop to see the Military and Maritime Museum in the **Vieux Fort.** Besides the weapons and other displays in the collection, there are military parades with 18th-century armaments and costumes on display.

A recent addition to the island is **La Biosphère** (160 Chemin Tour-de-l'Isle), not to be confused with the Biodôme at Olympic Park. Located in the geodesic dome designed by Buckminster Fuller for Expo '67, left vacant since a fire destroyed the acrylic skin of the sphere in 1976, La Biosphère was completed in 1995. Devoted to promoting awareness of the Saint-Laurent/Great Lakes ecosystem, the environmental attraction includes four exhibition areas, a water theatre, and an amphitheatre, and features multimedia shows and hands-on displays that encourage interaction. Open June through September daily from 10:00 A.M. to 6:00 P.M., and October through May Tuesday to Sunday from 10:00 A.M. to 5:00 P.M.

JARDIN BOTANIQUE (Botanical Gardens)

A few quiet hours in the 80-hectare (200-acre) grounds of the Botanical Gardens (Métro: *Pie Ix*) are a refreshing change from Montréal's fast pace. In warm weather all the 26,000 different species and varieties of plants here are on display in formal and informal plots laced with walkways and the tracks of a miniature sightseeing train. Plants are identified by the Latin or scientific name and the English and/or French common names where applicable.

The park, started in 1931 by a local botanist, Brother Marie-Victorin, is open daily; admission is charged from mid-May to mid-October (no charge for the outdoor gardens the rest of the year). Cacti, tropical plants, and others requiring special environments are nurtured in glass conservatories, which can be seen even when snow covers the acres of outdoor gardens.

Olympic Stadium in Maisonneuve Park next to the Gardens was the site of the 1976 summer games; the mammoth stadium can seat over 70,000 people, and the swimming complex boasts half a dozen pools. Each has a different purpose, from the Olympic-size racing pool to a scuba pool 15 metres (50 feet) deep. Guided tours of the Olympic Stadium are offered daily. The park also contains the **Olympic Tower,** the world's highest inclined tower at 190 metres (633 feet). Trips can be taken to the top by cable car (closed mid-January to mid-February; admission is charged).

The bold conception of the Olympic facilities is typical of Montréal, but it caused problems as well. The city, the province, and all Canada were enthusiastic and attentive hosts for the games, but the costs of construction and the apportioning of the expense remained hotly debated topics for some time after the games, especially when it was decided the citizens of Montréal would pay the bill.

Jean Drapeau

In 1954 a report was issued by Judge Caron of Montréal, who had been looking into corruption and moral decline in the city. The Caron report was a bombshell; in effect, it said that no Montréaler could be proud of such a city. Only three weeks after the report was released, one of Judge Caron's chief investigators, 38-year-old Jean Drapeau, was elected mayor of Montréal on a reform ticket. Three years later, he lost the seat to a rival candidate, but in 1960 the electorate decided that Drapeau was indeed the better man, and he was swept into power again and served as mayor for many years. Though some of his bold plans were highly controversial, most Montréalers credit him with being the founder of the "new Montréal."

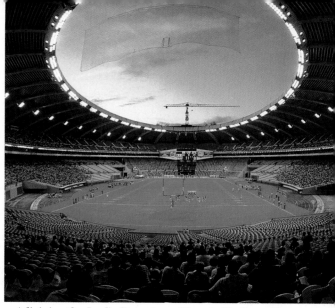

*Adjoining the Jardin Botanique, Olympic Stadium offers
refuge for pleasure-seekers of a different sort.*

Another interesting environmental attraction that makes
use of a previously-built structure is the **Biodôme de
Montréal**, 477 avenue Pierre-de-Coubertin, located in
what used to be the Vélodrome that was constructed for
the 1976 Olympics. The former bicycle-racing stadium
has been converted into a natural history exhibit of four
distinct ecosystems—a boreal forest, a tropical forest, a
polar world, and an environment resembling the Saint-
Laurent—that include some 4,000 creatures and 5,000
trees and plants. Open daily 18 June through 9 September

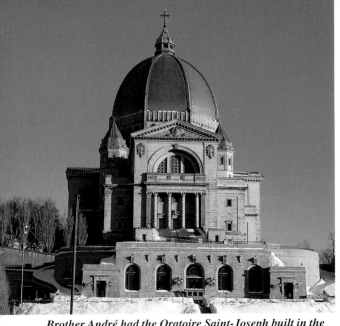

Brother André had the Oratoire Saint-Joseph built in the name of a fellow healer.

9:00 A.M. to 8:00 P.M., and 10 September through 17 June 9:00 A.M. to 6:00 P.M.

ORATOIRE SAINT-JOSEPH
(St. Joseph's Oratory)

From the city's high points, the huge dome of Oratoire Saint-Joseph (Métro: *Snowdon* or *Côte-des-Neiges*) overlooks Montréal. Brother André, a humble monk of the Holy Cross order, found that he had miraculous powers for

curing people, a service he performed faithfully until his death in 1904. St. Joseph, Patron Saint of Canada, was known as the healer of the sick, and Brother André's dream was to have a place of worship erected to the saint's glory, a wish that later came true. Brother André was beatified in 1982, and since his death his tomb has been a place of pilgrimage for the sick. The magnificent oratory offered an even greater inducement for those in need to come and visit this "Canadian Lourdes." Services in the chapel (1904), the crypt-church (1916), and the basilica (completed in 1960) are usually held in French.

Brother André's tomb and a votive chapel that houses the crypt-church are on the entry level. Elsewhere in the oratory you'll see replicas of some of **the rooms** in which Brother André lived, worked, and died, in addition to photographs and memorabilia of

> **In French the function of the period and the comma in numbers is reversed: 1.700 – one thousand seven hundred; 1,70 – one dollar seventy.**

him, a 15-minute film about his life and work, a museum, and the impressive **basilica.** Though built on the classic plan, the basilica is modern in design and decoration. Its spacious nave is free of cumbersome detail, and only the most important features, such as the altar and the windows, are emphasized.

Up the hillside behind the oratory winds a path to the stations of the cross in a garden setting.

MONTREAL'S NEIGHBOURHOODS

Urban redevelopment has given Montréal many impressive landmarks, but the city holds far more than just big buildings and grand design. Many residential sections on the old-fashioned human scale are alive with daily neighbourhood activity.

To find diverting local colour, make your way to **Square Saint-Louis** via rue Saint-Denis going west from the Berri-de-Montigny Métro station. Saint-Denis is a lively university street, lined with cafés, sandwich shops, boarding houses, and small bistros. Several blocks up the hill is place Saint-Louis (Métro: *Sherbrooke),* a picturesque area of Victorian gingerbread houses contrasting with more modern outdoor murals. The charm of the square is diminished somewhat by the huge State Tourism School at the northeast end.

The southwest end of the square is connected to boulevard Saint-Laurent—a big shopping district—by **rue Prince-Arthur,** a fine pedestrian way paved in tiles and lined with shady trees. It also offers murals, little shops, and restaurants featuring exotic specialties. **Boulevard Saint-Laurent** is full of ethnic shops, bars, and clothes shops. The grocery stores carry foods from all over the world. Restaurants serve Polish, Japanese, Middle-Eastern, and especially Italian and Spanish dishes.

In fact the whole area between boulevard Saint-Laurent and Parc Lafontaine north to avenue du Mont-Royal has been undergoing a tremendous revival since the latter half of the 1970s. Housing has been modernized and many young professionals have moved in. Lots of small houses have been taken over and re-made into elegant boutiques, exotic clothing shops, grocery stores, cafés, restaurants, *cafés-théâtres,* and so on.

If the Saint-Laurent is Montréal's "Little Europe," Asia is ever-present on six blocks delimited by René Lévesque and Viger north and south, and by Sainte-Dominique and Saint-Urbain east and west (Métro: *place d'Armes).* Here you'll

Boulevard Saint-Laurent offers a mélange of shopping and eating establishments representing many cultures.

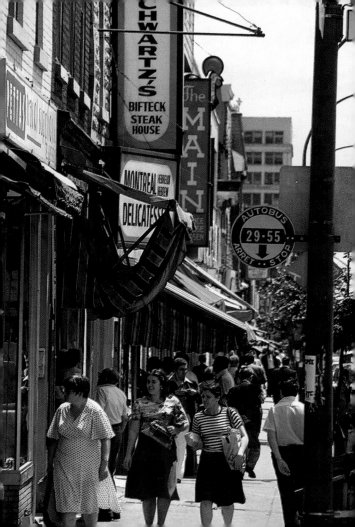

catch spicy aromas from Chinese restaurants and grocery stores. The Sino-Canadian community has set down firm roots, and many new buildings have gone up, funded by a new wave of wealthy immigrants from Hong Kong. Chinatown now appears to have little room for growth, except upwards. All this development has happened in the face of urban renewal officials, who covet this area on the edge of the financial district.

INTO THE LAURENTIANS

These gracious rolling mountains, an hour's drive north of Montréal, were first inhabited by Algonquin Indians looking for a safe place away from their enemies, the Iroquois. They also may have chosen the region for its natural beauty. Long, narrow glacial lakes are fed by freezing cold streams coursing down the mountains' wooded slopes of yellow birch, beech, pine, and maple. The small towns here make their living partly through the resort business, providing holiday accommodation, restaurants, hunting and fishing supplies, and necessary equipment for the many other sports here. The wild beauty of the Laurentians is preserved intact in the very large provincial parks and reservations, of which the most famous and popular is Mont Tremblant.

From Montréal you can easily reach the Laurentians by the Station Centrale (Voyageur) bus service (Métro: *Berri-de-Montigny)* or private car. Highway 15, the Autoroute of the Laurentians, is direct and passes near many small towns. Highway 117 takes up the route where 15 ends, to bring tourists within easy reach of the parks.

Laurentian beauty spots such as this confirm Québec as La Belle Province.

Several towns in the region possess monuments to Father Labelle, after whom one of the Laurentian forest reservations is named. Labelle is the man who did the most to settle the region. During the latter part of the 19th century, when Québecois were being drawn to New England textile mills by steady work and good pay, he encouraged people to move to and farm the Laurentian region. He explored much of the territory on foot and founded many Laurentian towns.

The Sugar Maple

The maple tree is Canada's chief symbol, with the famed red maple leaf the emblem of her flag. In the early springtime, usually about March, when the weather brings cold nights and bright warmish days, syrup producers head out to the sugar bushes (that is, groves of sugar maples) to put containers under the tapping pipes which have been driven into the maple trunks. When the sap is running at its peak, this process can result in a bucketful from each tree by evening. The sap is then taken to the sugar house, a structure housing large vats heated by wood fires. There it is boiled down for several days, until each 40 gallons of liquid is reduced to one gallon of light golden maple syrup with a very hearty flavour.

When packed in sterilized containers, maple syrup will last for many months; when crystallized it makes maple sugar candy. A touch of maple syrup added to *fèves au lard* is essential if the dish is to be authentic, and maple sugar pie is yet another not-to-be-missed Québec delicacy.

"Sugaring off," the pouring of the hot thickened sap of the sugar maple onto the snow, is fun for all the family and shouldn't be missed if you're in Montréal during the sugaring-off season in spring. Newspapers carry advertisements from syrup producers who welcome visitors; you can also contact the tourist information office for more information.

Today farming, tourism, and some industry (principally logging and paper-making) keep the mountain area prosperous without detracting too much from its natural beauty.

During the warm summer months, visitors enjoy many outdoor sports, especially lake activities such as boating, sailing, water-skiing, swimming, and fishing for speckled and lake trout, pike, bass, and other varieties of freshwater fish. Canoe or kayak trips, with camping out along the riverbank, are some of the best ways to appreciate the rugged splendour of the mountains. Hiking is another, particularly in the provincial parks.

In winter the Laurentian colours change from green and blue to white and gray, and crowds of skiers come to the ski runs on almost every hillside north of the town of Piedmont, 64 km north of Montréal, all the way to **Mont Tremblant Park.** The slopes of Mont Tremblant descend over 600 metres (2,000 feet) from summit to base, and are faced with some 105 km (65 miles) of downhill trails served by chairlifts and T-bars. It seems as though each of the large resort hotels (and even some of the more modest places) has its own mountain, lifts, ski school, and special attractions in the way of cuisine and aprés-ski entertainment. Cross-country skiing (*ski de fond*) is very

Homemade maple sugar candy is a rapturous re-discovery each spring.

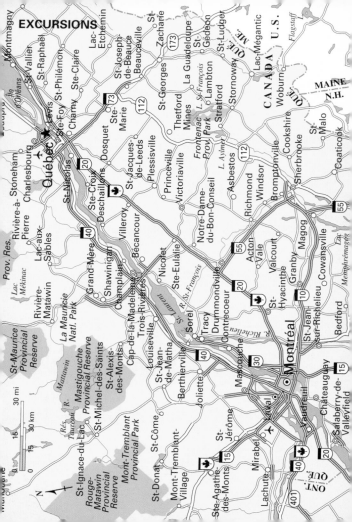

EXCURSIONS

popular. Most people who come to the Laurentians for skiing sign up for a "package" *(forfait)* including accommodation, meals, and lift fees for a weekend or a full week.

Proud owners of a new pair of snowshoes can try them out on the 10 km (6 miles) of snowshoe trails in Mont Tremblant Park, or at other centers.

Springtime brings "sugaring-off" (see page 56) in the groves of sugar maple trees; and in autumn it may be too chilly for a picnic, but just right for a drive to see the brilliant fall foliage.

CHEMIN DU CIDRE (The Cider Road)

If you have a car or rent one for a day, the autumn apple-picking season is a good excuse for a trip to the towns south and east of Montréal. Before you leave the city, check with the Centre Infotouriste on rue Square-Dorchester for news of current festivals, cider-making celebrations, and other special events. The "Cider Road" described here is a favourite Montréal outing.

Due south of Montréal is Huntingdon County, reached by Autoroute 15. Drive west along Highway 202, near the New York border, to the small town of Hemmingford. In mid-August the town holds its annual festival, when the orchards are full of heavily-laden trees and the cider houses give free tours. Handicrafts, antiques, and "precious junk" are on sale at sidewalk booths, and the atmosphere is heady, healthy, and happy. The festival is named La Semaine des Retrouvailles *(Old Home Week),* the theme of which is bringing former residents back to the area. It anticipates rather than celebrates the harvest season, as the fruit in the orchards is only ready for picking in September and October.

If you're near Hemmingford in late September or early October, be sure to go to one of the small number of arti-

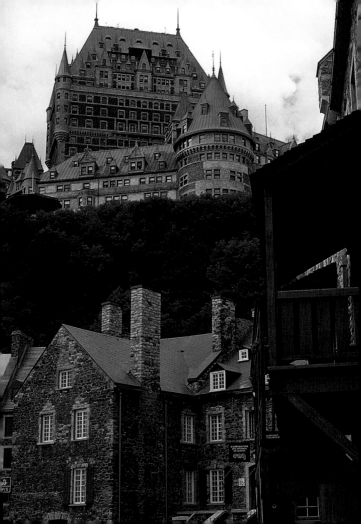

sanal cider-makers that produce from farms in the area. The Verger Du Minot at 376 Covey Hill Road, south of and parallel to Highway 202, is one such operation, set in a stretch of very attractive countryside. Tastings of the "wine of Québec" are provided. Reservations are often required at many of the cider houses, so plan your visit in advance. The area is also dotted with U-pick orchards, where those who prefer their fruit unfermented can walk in and pick right off the trees.

Hemmingford is also noted for its African Safari Park, a 160-hectare (400-acre) reserve harbouring lions, elephants, rhinos, and lots of other exotic creatures (open summer only).

You might also stop by to see Blair House, an historic old farm which has been restored and converted into the historical museum of the Châteauguay Valley.

A DAY IN QUEBEC CITY

Québec was the first French city in Canada, and is today the capital of the province of Québec and the home of the Québec parliament, called the National Assembly. French influence is clearly predominant here, and the English aspect is much less obvious than in Montréal.

The city's history matches the drama of its situation on Cap Diamant, an outcrop of rock commanding the Saint-Laurent. The explorer-trapper Samuel de Champlain founded the town in 1608, building a small fortified *habitation* (dwelling) near a good docking place on the shore, but soon moved to a more easily defensible cliff-top site near where the Château Frontenac stands today. Over the years the town expanded commercially as well as culturally as the fur-trade increased. A

Old Québec snuggles around Château Frontenac, which lends a fairytale aspect to the landscape.

Diocesan seminary founded here in 1663 became Laval University in the 1850s.

In 1759 the English sent a crack force of British marines and regulars to lay siege to the town; after almost three months of a standoff the British general, James Wolfe, succeeded in getting his soldiers onto the heights at the southern approach to the Upper Town. He was met by the Marquis de Montcalm

Dufferin Terrace offers dominating views of town and river.

and his troops. On the field now called the "Plaines d' Abraham," fierce fighting raged for less than a half hour, until the English won, taking the town. The two commanders were among the very large number of casualties.

Efforts to recapture Québec City failed, and French rule in Canada ended with the 1763 Treaty of Paris. The only subsequent threat to English rule was the abortive American attempts to do by force what they had not been able to do by propaganda during the early days of the Revolution. A company under Benedict Arnold was sent to take Québec City

and assure its support of the American revolutionary effort. On the last day of 1775, American forces attacked the Lower Town (plaques now mark the site of the battle) but were defeated and captured or forced to retreat. After this failed invasion Québec City lived in peace and prospered from its merchandise and its trade: furs, oils, lumber, shipbuilding, tanneries, furniture, and textiles.

Many of these commodities have now been replaced by the modern industries of tourism and government administration.

City Sights

The celebrated castle-hotel, **Château Frontenac,** completed in 1892 and owned by Canadian Pacific, has become the city's main landmark. Begin a tour of Old Québec with a stroll on **Dufferin Terrace** (1838) and the **Promenade des Gouverneurs** (1960), scenic terraces built on the edge of the cliff right in front of the château. There is a commanding view both summer and winter of the Lower Town and its place Royale, as well as of the Saint-Laurent and the city of Levis on the south shore. At the north end of the Terrace is an 1898 statue to Samuel de Champlain by sculptor Paul Chèvre. South from the monument the Terrace joins the Promenade, which extends all the way along the walls of the Citadel to Battlefields Park. Right next to Château Frontenac, the **Jardin des Gouverneurs** is a charming and peaceful patch of greenery lined with old mansions, many of which have been converted to small hotels and *pensions.*

On the north side of Château Frontenac, the **place d'Armes** lies in the great shadow cast by the hotel. Here is the center of Old Québec, once the garrison's training ground (hence the name) and its most important public square. You'll find the tourist office here, as well as the

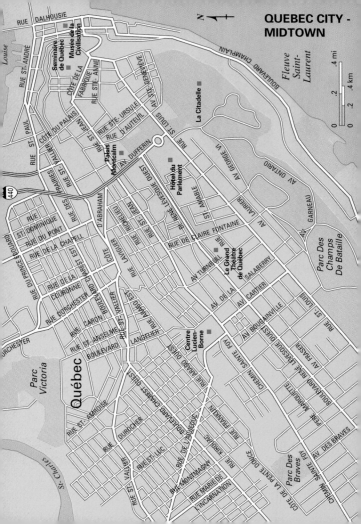

Whatever your taste, you'll find that Old Québec offers something to your liking.

Musée du Fort, in which a scale model of Québec City is used to bring to life the great battles of its past. Monument de La Foi *(Monument to the Faith)* in the center of place d'Armes pays tribute to the men who brought and spread the religion of France to the New World. On the place d'Armes, you can hire a *calèche* (carriage) to take you on a 35-minute tour of the city's historical sights.

Descending to the north rim of the escarpment, you pass the buildings of the **Québec Seminary,** founded in 1663 by the first Bishop of Québec, Msgr. François de Montmorency-Laval, and opened to students other than Jesuits in 1765. Adjoining the seminary is **Notre-Dame Cathedral Basilica,** first built in 1647 but ravaged several times by fire; the building you see is a 1920s restoration.

Other buildings in the old style on this side of town are the Crémazie House on the rue de la Fabrique, home of a renowned Canadian poet; the Garneau House, at the corner of Saint-Flavien and Couillard, named after the French Canadian historian who gave French Canadians a full sense of their identity in his *Histoire du Canada;* and the Touchet House at the intersection of Sainte-Famille and Hébert, over two centuries old and decidedly French.

Through the city walls and down the side of the escarpment you'll reach **Québec's Lower Town** and the place Royale, which is almost directly beneath Château-Frontenac. Here is the route that Benedict Arnold and his American forces followed to attack Lower Town.

> **Fuel types for cars/trucks:**
> unleaded (*sans plomb*),
> regular (*ordinaire*),
> premium (*du super*),
> diesel (*gas-oil*)

After the American defeat, captured American officers were trooped up the hill to the Québec Seminary and held there as prisoners of war.

The **place Royale,** the site of Champlain's very first settlement in Québec, was the center of Québec life from 1608 till 1759, when during the great siege of Québec the English cannons damaged many of the old buildings and set others afire. This destruction of the unfortunate Lower Town prompted many of the wealthy merchants who had made their fortunes on the river to move to Upper Town, where the new English rulers of Québec were building strong defenses. During the later 19th and early 20th centuries, the ancient buildings in Lower Town were often razed to make way for the warehouses, repair shops, and other businesses which invaded the waterfront. But since the 1970s the area surrounding place Royale has undergone extensive restoration to bring back its 17th-century aspect, with very suc-

cessful results. The name of place Royale derives from the bust of Louis XIV in the center of the square. The present version (1928) is a replacement for the original erected in 1686, the 43rd year of his 72-year reign.

Notre-Dame-des-Victoires is an attractive small stone church facing the square. Built in 1688, it had to be restored after the 1759 bombardment. The name dates from the second French victory over the English in 1711—the first victory was over Phipps in 1690.

Of the many finely restored houses and shops in the Lower Town, don't miss the **maison Chevalier,** an odd grouping of three adjoining but distinct houses with old Québec furnishings. See also the **maison Dumont,** home of the Maison des Vins (see page 97), which has opened its cellars to visitors, and the house of Louis Jolliet, the great Québec-born explorer and fur trader who, along with Jacques Marquette, explored the Mississippi River all the way to its confluence with the Arkansas, 2,000 km (1,300 miles) from Québec. (His name was given to a town in Illinois.) Jolliet's house is the lower terminus of the funicular which takes you up to Dufferin Terrace.

At the th end of the terrace is the place d'Armes. From this square, the rue Saint-Louis heads southwest towards some of Québec's grandest modern buildings. The **Convent des Ursulines,** a huge complex covering 2.8 hectares (7 acres), was founded in 1639 but has been rebuilt several times following fires. Two blocks farther along, the Parc de l'Esplanade offers a restful field of green shade. The Québec Urban Community tourist office is to be found in the park.

The Citadel is an impressive monument approached up a hill and through a stone-lined entrance. The original French fortifications here are topped by the British version (1820), which took 30 years to complete. The fortress was manned by British troops for a mere 20 years before the garrison was re-

placed by Canadian troops. Changing of the Guard is at 10:00 A.M. daily (except when raining), mid-June to Labour day; Beating the Retreat is at 6:00 P.M., Monday through Thursday in July and August. The Military Museum, housing trophies of the Citadel's Royal 22nd Regiment, also has artefacts from early Québec and a brilliant display of military costumes.

Except for the Changing of the Guard and Beating the Retreat ceremonies, visits to the Citadel are by guided tour only. Tours are run daily from April through October; from November to March only through group reservations.

Through the Porte Saint-Louis, (St. Louis Gate) the area to the right along the city walls is the center of carnival activity

Québec's artisans display their traditional wares proudly in charming stores and local galleries.

Certainly a sight to behold, Carnaval in Québec warms ten chilly days every February.

in February. Across avenue Dufferin are the parliament buildings of the Québec National Assembly erected in 1886 in 16th-century French style. Nearby, the modern buildings housing other government offices attest to the progressive spirit of Québec's citizens and planners.

Rue Saint-Louis becomes the Grande-Allée and continues past the parliament buildings to skirt **Parc Battlefields,** site of the Plains of Abraham. The **Musée du Québec** in the park is a treasure-house of the region's art, traced from its European origins up to the present. Highlights include a fine collection of carved wooden figures. It is open from 10:00 A.M.

to 5:45 P.M. daily in summer (closed on Mondays the rest of
the year). Admission is free on Wednesdays, when the muse-
um stays open until 8:45 P.M.

On the way back to the center of Old Québec from av-
enue Turnbull, you'll see **Le Grand Théâtre,** the city's
performing arts center and a symbol of the new Québec, in-
augurated in 1970.

Carnaval in Québec

In the pre-Lenten season, Québecois throw off their decorum
to indulge in a little mid-winter madness. Starting on the first
Thursday in February, the dreariest month of the long winter,
the quiet park facing the National Assembly becomes the
place du Carnaval, featuring a huge Snow Palace. Fanciful,
comic, or dramatic ice sculptures of gigantic proportions
are carved here, decorating the "palace square." Hardly
simple snowmen, these are highly competent works of art.
The only snowman-shaped figure is Bonhomme Carnaval,
the jovial spirit of this ten-day festival, always portrayed
with a red *tuque* (cap) and a colourful handwoven sash.

Two weekends and the week in between are hectic with
activities: hockey tournaments, the coronation of the
Carnival Queen, fireworks, a canoe race on the icy Saint-
Laurent, formal dances, and general celebrations. The
parades attract crowds of merry revelers, who careen
along behind the floats and bands. Fighting the cold
weather, trumpet-players play their instruments in special
muffs so the valves won't freeze. Onlookers keep warm by
sipping a lethal liquid called "Caribou" (sweet red wine
and grain spirits), sometimes carried in plastic Carnival
"canes" and "trumpets."

The Night Parade on the Saturday before the end of
Carnaval is the grand finale, and city hotels are booked to
capacity as special trains bring hundreds of revelers from
Montréal to share in the excitement. If you go, make
advance hotel reservations.

WHAT TO DO

THE MUSEUMS

The **Musée des Beaux-Arts** *(Museum of Fine Arts)* at 1379 Sherbrooke Street West (Métro: *Guy),* has a well-balanced collection of art from ancient times to the 20th century, arranged by period and geographical area. There's something here to suit everyone, which makes the museum a very popular place. European painting is well represented, with a good panorama from El Greco through Rubens to Picasso. There are ancient works from the Middle East, Greece, Rome, and the Islamic countries and African masks and statues, but the museum's best showpieces are the pre-Columbian figures. Other exhibits include Canadian paintings and furniture, and Inuit (Eskimo) figures and artifacts. You can buy a museum guidebook at the entrance or a less expensive brochure including a directory of the collections and a plan of the recently modernized and expanded museum building. The museum is open Tuesdays and Thursdays through Sundays 11:00 A.M. to 6:00 P.M, and Wednesdays 11:00 A.M. to 9:00 P.M.

McGill University's **McCord Museum,** 690 Sherbrooke Street West (Métro: *McGill),* offers a colourful display of Canadian and Eskimo objects. The emphasis is on artefacts from the history of Canada, including costumes, textiles, and a collection of fascinating pictures of early Canadian life.

The **Maison de la Poste** *(Post Office House),* 640 rue Sainte-Catherine ouest, is an extremely well-organized museum offering a complete range of Canadian stamps and at the same time a good opportunity to get acquainted with stamp production. Here you can see stamp blocks, corner blocks, first-day covers, complete panes, special albums, and

mounting sheets. Whenever it's a stamp issue day, activity is at its most hectic. An experienced staff is willing and able to help at all times with any philatelic problem.

The **Musée d'art Contemporain** *(Museum of Contemporary Art),* 185 rue Sainte-Catherine ouest, is reached by car, taxi or bus No. 12, which you take along University Street from place Bonaventure to Cité du Havre. Besides a permanent collection of works by Québec and other Canadian artists (including an interesting collection of Canadian wood sculpture), the museum features temporary exhibits from photography, painting, textiles, and sculpture, to any of the other traditional or off-beat media used today. One room in the museum is devoted to the paintings of Paul-Emile Borduas (1905–1960), the boy from rural Québec who became

Before the settlers—preserved in the McCord Museum, early artifacts record a way life from another century.

one of Canada's major abstract painters. The museum is open every day but Monday. Wednesday evenings are free.

The **Centre d'Histoire de Montréal** *(Montréal History Center)* at 335 place d'Youville (Métro: *Square Victoria*) depicts the cultural history of Montréal from 1642 to the present. Guided tours are run and there are frequent temporary exhibitions.

The museum is open daily mid-May to mid-September, from 10:00 A.M. to 5:00 P.M.; the rest of the year Tuesday through Sunday, from 11:00 A.M. to 5:00 P.M.

The **Musée Redpath** (Redpath Museum) at 859 Sherbrooke Street West (Métro: *McGill*) has a rare fossil exhibition including dinosaur bones. Two Egyptian mummies are displayed in its anthropological collection. It is open from September through June weekdays from 9:00 A.M. to 5:00

Visit Montréal's Musée des Beaux-Arts for its superb collection of pre-Columbian figures.

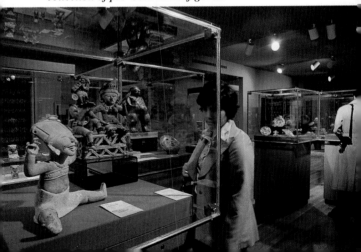

P.M. and Sunday from 1:00 P.M. to 5:00 P.M.; July and August Monday through Thursday from 9:00 A.M. to 5:00 P.M. and Sunday from 1:00 P.M. to 5:00 P.M.

Some magnificent railway coaches are shown at the **Musée des Chemins de Fer** *(Canadian Railway Museum)* which also exhibits streetcars, quaint locomotives, and other railway memorabilia. Located in the Montréal suburb of St. Constant (tel.: 514-632-2410), it displays over 100 cars and engines from all periods of railroad history and you can

Picturesque Old Québec is a delightful place to explore on foot.

even ride in one; each weekday a streetcar takes visitors on a short run, and on Sundays they even stoke up one of the old trains for a short trip into nostalgia. The museum is open daily in summer only and weekends through October.

The **Planetarium de Montréal** (Métro: *Bonaventure)*, at rue St-Jacques (and rue Peel), several blocks southwest of place Bonaventure, has interesting shows in English every afternoon and evening except Monday from 29 January to mid-June and Labour Day to 18 December; open 24 December and 2-8 January. The current show is usually advertised in the entertainment section of *The Gazette*, or phone 514-872-4530 for information.

A bookshop in the lobby sells publications on astronomy as well as scientific games.

SHOPPING

Montréalers love to shop, and no wonder. The choice of goods in the temptingly full shops is overwhelming and each new shopping area is a cause for real excitement. Canada's close links with France, famed for its elegant women, and England, renowned for its well-dressed men, have given rise to stores ranging from branches of leading London shops to windows dressed with displays that rival even the most elegant Parisian boutiques.

The Old Guard in shopping are the large department stores on rue Sainte-Catherine, many of which have been here for over a hundred years. Ogilvy's, 1307 rue Sainte-Catherine ouest, was founded when the Scots were lords of Montréal's business world, and every day, a bagpiper goes the rounds of

Shoppers are offered many choices in Montréal, from hand-made crafts to haute couture.

the five floors, piping merrily at opening, closing, and noon. The store has been remodeled and is now a collection of designer boutiques, with most of the top couturier represented.

Eaton's (Sainte-Catherine at University), is a practical store, and sells products that are of good value. New Yorkers might think of it as "Montréal's Macy's," as it is the city's largest store.

Another store is run by the Hudson's Bay Company, the historic firm set up to exploit Canada's fur wealth. Called the Bay (or *La Baie),* at Sainte-Catherine between Union and Aylmer, it sells everything but is most famous for its furs and fur products, of course. Furs are not exactly to everyone's taste, and they're not cheap here (except during the price-blasting sales); but a fur garment can be restyled and

tailored to suit changing fashions. Used fur coats may sell for a few hundred dollars; new coats cost, of course, considerably more, depending on the type of fur and style.

Finally, Montréal's last word for high fashion—and high prices—is Holt Renfrew, the very posh store at 1300 Sherbrooke West, two blocks from Sainte-Catherine. The latest Parisian fashions appear quickly in Holt's plush displays, as do the customers to buy them.

All of these large department stores have branches throughout the city, sometimes large, sometimes small, often located in the subterranean shopping complexes.

Montréal is well endowed with fancy new shopping malls. Les Cours Mont-Royal at 1550 Metcalfe Street, was transformed in the late 1980s from the well known Mont Royal Hotel into a major shopping center. It contains over a hundred boutiques on four levels and is worth visiting if just to appreciate the architectural beauty of the building.

The Eaton Center is the largest of the city's shopping centers (see page 45). It is at 705 rue Sainte-Catherine ouest. Place Montréal Trust, on McGill College Avenue, is also noted for its architecture, as well as its specialty shops. Next door, at 677, is Eaton's (see page 77).

For interesting boutiques, used goods, antiques, craft items, and, in general, the key shops that come and go quickly, make your way to Crescent Street and its two neighbours, Mountain and Bishop streets, between Sainte-Catherine and Sherbrooke. Also, keep your eye out for shops selling such items during your stroll through Old Montréal, especially rue Saint-Paul and rue Notre-Dame. You will find a few similar shops on Saint-Denis (Métro: *Berri-de-Montigny),* between boulevard de Maisonneuve and rue Marie-Anne, as well as on rue Prince Arthur and avenue Duluth on the Mont Royal plateau.

Carved wooden figures from Québec can range from rough caricatures to this refined rocking-horse.

Local Crafts

Products of Québec craftsmen and artisans are sold in several large specialty stores. The largest selection of crafts may be found in stores called "Le Rouet." The biggest is on Sainte-Catherine between University and McGill. The branch in Old Montréal is open late from Thursdays to Saturdays. For last-minute buys, try the duty-free section of Mirabel airport. Here are some shopping ideas:

Québec carved wooden figures: an old traditional art; the wizened and bent old men who practice the craft always have a jovial, cheerful look, as though they know the secret of a happy old age (is it being a woodcarver?). There's great variation from the very rough to the quite refined, that's reflected in the price.

Rag dolls: variations on the "Raggedy Ann" design.

Patchwork quilts make excellent gifts, if slightly pricey.

Indian moccasins: the real thing, practical and colourful.

Mukluks: bulky boots, made of fur and sealskin, that keep an Eskimo's feet warm.

Eskimo soapstone (steatite) carved figures vary colossally in artistry and in price.

Eskimo pipes with wooden stems and soapstone bowls, which look like indian "peace pipes."

Snowshoes: authentic wood and gut, very durable.

Prints on rice paper done by well-known Eskimo artists; each print is titled, signed, and dated in English or French as well as in Eskimo runes. Most are collectors' items.

Baskets: birchbark and wicker or grass.

Traditional wooden furniture, rag carpets, and handwoven textiles are also on display.

Another place to buy craft items is the Guilde Canadienne des Métiers d'Art Québec (*Canadian Guild of Crafts*), 2025 Peel Street. Here, Eskimo carvings in steatite, calcite, and serpentine with ivory accents are displayed in glass cases; the selection is limited and very fine. Modern textiles also usually have a prominent place in the Guild's window, along with a variety of other items including attractive small wooden molds in the shape of maple leaves for making maple sugar candy.

There's a nice little museum in an upstairs rear gallery featuring a selection of outstanding craft items.

Outdoor Markets

In summertime Montréal's outdoor food markets are bustling, full of colour and tempting smells. The city's largest is in the heavily Italian neighbourhood near the Métro's Jean-Talon station. From the station walk southwest on avenue Jean-Talon, and after two blocks go southeast to Mozart Street. Market specialties include most of the things you'd find in a similar market in Genoa or Pisa, but the produce is from the rich countryside of Québec.

Another outdoor market, closer to downtown, is the one on Atwater Avenue, near the Métro stop of the same name. Both markets are open daily in summer (the indoor part of Atwater market is open all year round).

The early-birds who show up at seven in the morning get the first friendly smiles from the vendors and have the pick of the stalls' burdened shelves, but this isn't the time for bargaining—with the day still ahead of them, vendors don't feel much like cutting prices. Shoppers who arrive at 10:30 or 11:00 A.M. find the market area crowded with people, great quantities of tomatoes, apples, and chickens disappearing into shopping bags, and price competition among vendors getting heated. Late afternoon or Saturday evening shoppers who stay away until the market is near closing get the pick of the prices, but not of the goods.

Don't miss a day of skiing in Montréal: the conditions here are "best in the East."

SPORTS

Montréal is sports-mad and dozens of different sports are played at the amateur and professional levels. Bowling on the green, skeet shooting, and curling are among the ways

Sports-mad Montréalers usually pack the Molson center to watch Les Canadiens play hockey.

Montréalers keep trim. Sports pages in the newspapers, both French and English, give information about the major sports. For the minor ones, telephone Sports Québec at 514-252-3114. This organization represents all the sports federations in the province. Here's a rundown on some of the popular sports you may want to look into:

Baseball: The Montréal Expos (National League) play about from April through September in the Olympic Stadium. Ticket reservations can be made by calling 514-253-3434 or 800-463-9767.

Car Racing: The Grand Prix Molson du Canada, a Formula One car race, is held yearly in June on Ile Notre-

Dame at the Gilles-Villeneuve track near the entrance to the Voie Maritime du Saint-Laurent.

Cycling: Bicycle racing is a typically French passion and is very much alive in Montréal. The Grand Prix Cycliste d' Amerique (World Cup) race is held annually in early October over a distance of 224 km (140 miles). Le Tour de l'Ile de Montréal (first Sunday in June), on the streets of Mont Royal, is a day-long race with 120,000 spectators (tel. 514-847-8356) and attracts professional cyclists from around the world.

As for amateur bicycling, downtown traffic is so dangerous and the city's hills are so tiring that you'll see few bikes in the city. But the province in general is addicted to two-wheeled exercise. Québec claims to be the second city in the world in terms of bikes per capita.

Fishing: Québec boasts thousands upon thousands of lakes and streams, and huge numbers of fish are caught in them annually. The variety of fish to be caught in Québec is impressive, and includes all sorts of trout, pike, walleye (the much-valued core of Montréal restaurants), bass, perch, muskellunge, and in some parts of the province, sturgeon and salmon. Call the Ministère du Loisir, de la Chasse et de la Pêche (MLCP) for suggestions as to where to fish.

Hockey: The Montréal Canadians (*Les Canadiens*) of the National Hockey League are the city's stars in the firmament of sports. From October to April the centre Molson, opened in 1996 at 1260 rue de la Gauchetière (Métro: *Bonaventure*) replaced the old Forum (Métro: *Atwater*) is packed with cheering fans, and tickets are at a premium. Try to reserve places before you get to Montréal, for once you arrive it may be impossible to find them.

Horse Racing: Harness racing (pacers and trotters) at the Blue Bonnets Raceway at 7440 boulevard Décarie at avenue

Jean-Talon, all year round. The sport is well developed in Montréal and is worth going to watch.

Hunting: The big game in Québec is moose, caribou, black bear, and whitetail deer; fowl include partridge, duck, and Canadian goose. The province is divided into zones with different regulations. Arrangements for a hunting trip are best made through one of the many outfitters who specialize in this service. Lists of outfitters are available from the Fédération des pourvoyeurs du Québec at 5237 boulevard Hamel bureau 270, Québec G2E 2H2; tel. 800-567-9009; www.fpq.com.

Sailing: The city has a dozen yacht clubs, and sails fill the Saint-Laurent each summer day. For information, contact the Fédération de Voile du Québec through the office of the leisure association of Québec, at 514-252-3000.

A Boat Ride on the Saint-Laurent

A great way to get out of town is a boat ride around the Port of Montréal, the islands, and the Saint-Laurent. Tour ships of Montréal Harbour Cruises Inc. (Les Croisières du Port de Montréal) depart for cruises in the port and the Saint-Laurent several times a day between May and October from The Clock Tower Pier, at the foot of Rue Berri. The classical cruise lasts 1½ hours and will take you around the port and past the Olympic sites on Ile Sainte-Helene, as well as near the first locks of the Voie Maritime du Saint-Laurent. A bar for refreshments and snacks, plus a running commentary on the history and activities of the harbours and the sights of the city skyline and Old Montréal keep passengers entertained. You can also join the "Sunset Cruise," the "Love Boat Cruise," or the "Sunday Morning Champagne Brunch Cruise." For further details, call 514-842-3871.

Skating: In winter there are rinks and ponds for ice-skating all over the city. A particular favourite, set in woodland, is Lac des Castors in Parc du Mont-Royal. For conditions at others, call the Parks and Recreation Department at 514-872-6211.

Skiing: Conditions are billed as "the best in the East," the season is long, and there are areas to suit all tastes. The two types of skiing, downhill *(ski alpin)* and cross-country *(ski de fond)* are often (but not always) found side-by-side. Even if you plan to visit only Mont-réal itself, bring your cross-coun-try skis for a run through Parc du Mont-Royal. Major ski regions are: the Laurentians, easily acces-sible by bus and expressway from Montréal; southern Québec near the New York Vermont border; and the area around Québec City. For information on events, contact the Fédération Québécoise du Ski, 4545 Rue Pierre de Cou-bertin, C.P. 4000, Succursale M, Montréal HIV 3R2 (tel. 514-252-3089). For snow conditions, check the daily news-papers, radio and TV stations, or call the Québec Tourism Offices at 514-873-2015 or 800-363-7777.

> **Signs:**
> *Baignade interdite*
> – No swimming

Snowshoeing: Trails are usually laid out along with the cross-country skiing trails. The most exciting ones are in provincial parks.

Tennis: The City of Montréal operates numerous outdoor and indoor courts for residents and visitors alike. The num-ber to call for information about tennis is 514-872-6211.

NIGHTLIFE

Montréalers are as keen about going out on the town as they are about shopping, and the city is alive every night of the week, except perhaps Sunday, with entertainment ranging from the expensive discothéques and supper clubs of the

Catch a hockey game, snack on pork and beans, or just enjoy a good beer at a Montréal tavern.

downtown hotels to the erotic movie houses and topless bars of rue Sainte-Catherine est.

There's also plenty of evening fun for the young, from movies in the underground city to discotheques at the top of skyscrapers. Every season there's a new "in" place (often the most recently opened), and long lines form at the door; some hopefuls never do see the inside. First-run movies are often mobbed, and crowds have to be organized with a loudspeaker. The secret is to go early.

Though most of Montréal's theatre activity is in French, the Centaur Theater in Vieux-Montréal (453 rue St-François-Xavier; tel. 514-288-3161) and the Saidye Bronfman Center (5170 chemin de la côte Sainte-Catherine; tel. 514- 739-2301/7944) put on both traditional and experimental plays in English. Concert activity is centred on the place des Arts for symphonic music and ballet, and the Forum for pop and rock. Newspapers and the city's *Calendar of Events,* issued free at hotels and tourist offices, have details of current entertainment options.

The famous *chansons* with their songs and ballads are now well on their way out and have been replaced largely by *cafés-théâtres,* cafés where theatre performances are given. A real Québec specialty, these are something everyone can enjoy by the young and well of skyscrapers. Every season there's a new *joual,* the nuances of which only a native will really appreciate.

For light entertainment on summer evenings, there's a lot of impromptu music in the parks, such as Lafontaine Park, for all to enjoy, after which it's pleasant to go and have a drink at a terrace on rue St-Denis or Prince Arthur.

Drinking Places

The Québecois go to the tavern to unwind, not to be on their best behaviour. Until the 1980s, women were excluded from these establishments by law. The taverns can be lively, even boisterous places if a hockey match is on the TV, but you may have to pick up a bit of the local French dialect before conversation comes easily.

A *brasserie* (literally, a brewery) is a more congenial place for visitors to meet Montréalers or other travelers; and women are likely to feel more at home here. Though not really breweries, *brasseries* offer beer both in bottles and on tap (*bière en*

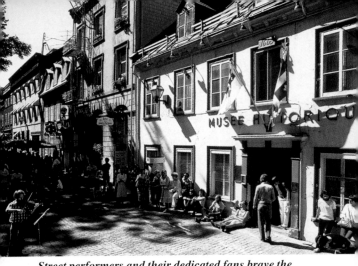

Street performers and their dedicated fans brave the summer heat for the love of music.

fût) and also cider. *"Mets"* (meals) of the rough-and-ready variety are almost always offered, and the list may include an *assiette Québécoise* (Québec plate) of pigs' knuckles, pork and beans, meatballs, and *tourtière* (meat-and-potato pie) with French fries (chips) at a reasonable price.

To see and be seen, you'll have to go to one of the pubs or bars on Crescent Street: shoulder your way in and then try to look as though you've been there forever. While the Crescent Street pubs—some of which are authentically English—and the bars attract the young, affluent, and beautiful, there are others in quieter districts for the business set or the Irish dreaming of home. The bars in the big hotels cater mostly to their residents and tend not to be very lively.

Festivals

Though local celebrations, fairs, and festivals are held in various Québec towns throughout the year (see also PUBLIC HOLIDAYS in the Handy Travel Tips section of this book) the most famous and colourful are these:

Québec Carnival (see page 71), held every year for ten days beginning on the first weekend in February, is a midwinter festival without parallel. Every hotel room in town is booked in advance.

Carnaval-Souvenir de Chicouti, a celebration similar to the one in Québec City, is held for 10 days in February after the latter ends. Chicoutimi is about 95 km (150 miles) north of Québec City.

St. John the Baptist Day (Fête de Saint-Jean Baptiste), June 24, is a day of carnival and merrymaking in Montréal and other towns and cities of Québec. Fireworks, dancing, and special programs highlight the feast of the patron saint of French Canada. This is a uniquely Québécois celebration, not observed in other Canadian provinces.

Montréal Jazz Festival is a huge street party with many large, free concerts as well as the regular costly variety. It runs from late June into early July.

Fête des Environs is a three-day event which takes place in mid-July in the city of Sherbrooke, about 100 km (60 miles) east of Montréal. Its highlight is a water-skiing competition.

The Québec Summer Festival (Festival d'été), held in July, with its dancing, shows, parades, and sports events, is rapidly gaining in popularity.

Montréal World Film Festival. Art and cinematic work from around the globe, with a variety of filmmakers represented. It runs from late August to early September.

EATING OUT

In the French tradition of *haute cuisine* dining is the day's most important activity. Combine this tradition with the Montréalers' love for a night on the town, and the result is a fairground of culinary delights, with food from many countries readily available. Restaurants range in price and quality from simple to sophisticated, and most Montréalers are willing to pay well to eat well. Note that a 15 per cent tax will be added to any meal check and a tip is expected in addition.

Breakfast: This hearty repast usually follows the American and British pattern: bacon and eggs (and the bacon is "back bacon," or "Canadian bacon" for outsiders), hot or cold cereals, griddle cakes with *sirop d'érable* (maple syrup), toast or doughnuts *(beignet),* and cof-fee. But French-style breakfasts of *café au lait* and flaky croissants are also served. Almost any coffee shop serving breakfast will have waitresses who understand your Franglais order for *deux œufs sunnyside-up.* Refills on coffee are free in most places. Breakfast is served between about 7:00 and 11:00 A.M.

> Male members of hotel staff are called *monsieur* (mursyur), female members *madame* (mahdahm) or *mademoiselle* (mahdmwahzehl) This applies to waiters/waitresses as well. Many people nowadays regard the word *garçon* as old fashioned and improper.

Lunch: The business lunch *(déjeuner d'affaires)* is well established in Montréal restaurants. Though sometimes strictly *table d'hôte,* a fixed-price menu, there's often some choice in the soup, main course, and dessert courses. Besides the fixed menu, you can also have the a la carte luncheon, with prices substantially lower than those for the same dishes on the dinner menu. Prime lunch hours are 12:30 to 2:30 P.M.

Dinner: Chefs save their prize recipes for the main performance, the evening meal. Service is generally polite and attentive, without the affectation sometimes associated with restaurants in the French tradition. You will find the waiters willing to help you select your food and wine and, in fact, it is a good idea to ask if the chef has a specialty that is not on the menu.

Reservations are required and respected, punctuality is encouraged, and local etiquette demands that bookings be cancelled by phone if you change your plans. Most restaurants open for dinner around 5:30 or 6:00 P.M., and often stay open till midnight or later. On Sundays these times are an hour or two earlier. There are, however, a good number of restaurants and cafés in Montréal where you can eat at any time of the day, and one or two operate round the clock. If a restaurant closes during the week it is usually on Monday.

"Dinner and a show" is not the style in Montréal. The dinner is the show, the show an added extra—and one that shouldn't be rushed for.

Types of Restaurants

Deluxe: All the large downtown hotels have one or more restaurants, and most are patronized by opulent Montréalers as well as visitors. The service is dignified, the wine cellar is often very good, and the menu tends to be the well-known rather than the *recherché:* frogs' legs in garlic butter *(cuisses de grenouille à l'ail),* tournedos of beef, and *coquilles Saint-Jacques* (scallops in cream sauce in a seashell, sprinkled with Parmesan cheese and baked). Every now and then moose or bear steak may be offered just to show this is Canada and not France. The word moose *(orignal* in French) may have a comical ring to it, but once you have tasted this sublimely tender and flavourful meat you may well find it diffi-

cult to go back to beef However, prices in deluxe restaurants are inevitably high, and the cost of wines can be exorbitant.

Small and cozy: Montréal has many small bistros where you'll find real culinary adventure. Dishes from the classic French repertoire will always be available and Québec produce will dictate the rest: fish from the lakes and rivers and meat dishes based mainly on pork. The rue Saint-Denis area and the streets of Vieux-Montréal abound with these gourmets' retreats.

Ethnic restaurants: The fourth dimension in Montréal dining, after French, *Québécois,* and American, is the international one. Since the time when the first three types were established here, many new groups have immigrated to Montréal bringing their distinctive dishes, with excellent results: won ton soup, Portuguese octopus stew, moussaka, and cannelloni are all readily available, either in fine recipes that approach *haute cuisine,* or in robust, popular versions.

Sidewalk cafés: The coffeehouse tradition has caught on in a big way in Montréal. In the past there were few streets with wide enough sidewalks for proper cafés: and also, Montréalers are so purposeful that they didn't go to a café simply to relax and do nothing. Now they've taken lessons from their cousins in Québec City, who find it very easy to casually chat with friends over a coffee or beer. In summer, the best areas for sitting and dawdling are rue Saint-Denis between Maisonneuve and Marie-Anne, and place Jacques-Cartier in Vieux-Montréal.

Montréal Cuisine

Here are the highlights of the city's varied menus:

Soups

The classic French onion soup is often served—and is often disappointing. Certain chefs assume it is simple to make, and

end up with something that tastes more of salt or bouillon cubes than of onions. The *soupe aux pois,* made the Québec way with yellow peas, is a much better bet. *Bouillabaisse* (fish chowder), different from its Mediterranean relative, is often outstanding.

Fish

Québec is justly famed for its fish, both fresh- and salt-water. First among them is the *doré* (walleyed pike/perch), a fish of firm white flesh and exquisite flavour. The best is the variety known as *doré noir,* somewhat less tasty, but still delicious, is the *doré jaune.* Prepared in many ways, it is usually served as a filet, perhaps *aux noisettes* (with hazelnuts).

The delicious selection of trout *(truite)* available in Montréal is second to none. Speckled, rainbow, brook trout, and

Outdoor cafés on cobbled streets—sometimes it's easy to forget that Montréal is in North America.

others may come poached or sautéed with almonds *(amandine)* in the classic manner of French cuisine.

In addition to *doré* and trout, other fish, including seasonal sturgeon and salmon, are served in Montréal. Species of fish not native to Québec waters are frequently shipped in, bringing even more variety.

Fowl

Chicken and turkey are common on Montréal menus, but the real stars are duck *(canard)* served with traditional orange sauce or with maple syrup (a delectable variation), partridge, grouse, and goose *(outarde)*.

Meat

Beef is always available, but pork is the basis of Québecois meat dishes, whether it be a piece of fatty bacon which flavours *fèves au lard* (pork and beans), or thick pork chops cooked in apple cider. Traditional favourites are pigs' feet, hocks, or knuckles stewed or braised—hearty and full of flavour—or *andouillette aux fines herbes,* flavourful pork sausage sauteed with delicate spices. Less exotic are the *boulettes* (meatballs) stewed in a rich tomato sauce. The star of regional cuisine is *tourtière,* a meat pie which, to be authentic, must be made from venison, partridge, harem, and finely chopped potatoes. More often these days it's made with pork, veal, chicken, and minuscule bits of potato. It can range in quality from a hearty, full-flavoured dish to a bland meat pie, often depending on what you pay for it. *Cipaille* is a similar pie, but layers of meat-and-potato filling alternate with six layers of pie crust. Finally, Québec chefs (and housewives) make a kind of pate called *cretons* from minced pork cooked with spices.

Montréal's big lunch dish is smoked meat sandwich *(sandwich de bœuf fumé).* Large chunks of beef are spiced and

smoked, then sliced, put between dark or light rye bread, and garnished with dill pickle. The home stretch for this Canadian corned beef special is boulevard Saint-Laurent near place Saint-Louis. Each delicatessen here has its own variations of the sandwich.

Salads

In true French tradition, salad is usually served as a separate course, after the main course but before the cheese, to clear the palate and aid digestion. Sometimes it is served American-style as a first course.

French food is appreciated by Montréalers of both language communities.

Vinaigrette (oil, vinegar, garlic, salt, and pepper) is a popular salad dressing, but the vinegar may well be from cider rather than wine as it is in France. Vinegar is also often used as a garnish for French fries (chips), instead of ketchup.

Cheese

A big selection of imported cheeses is offered in Montréal's restaurants and markets, but the most notable local cheese was first made in Oka, from which the cheese takes its name. With a fine white mold like Camembert or Brie, a well-aged Oka's texture slightly resembles fresh Munster; the flavour is

somewhat stronger than Brie. It's delicious! And Québec produces 50 more cheeses worth trying.

Desserts

French pastry is a favourite all over the city, but the regional specialty is maple sugar pie *(tarte au sucre)*, a sweet, heavenly concoction of eggs, brown sugar, maple syrup, butter, chopped nuts, a few drops of vinegar, and a pinch of salt. It often comes with whipped cream, absolutely delicious and wicked for a diet. When the fruit is in season, tasty *tartes* are also made from *bleuets* (blueberries) and *pommes* (apples).

Cider, Wine, Beer—or Spirits?

"Cider" means many different things in Montréal. *Cidre* is not found in restaurants, but in *brasseries,* taverns, and some cafés. Triple Six, a popular brand, is typical of *cidre léger* (light cider); it comes in a soft-drink bottle and looks like effervescent mineral water. It's deliciously dry and tart, and has about the same alcoholic content as beer. Some other brands of effervescent cider come in brown bottles and are the golden colour of apple juice.

Casse croûte

Casse-croûte ("break a crust") might be what was done for a snack years ago in France, but in Montréal today a *casse-croûte is* a snack bar or light lunch counter. Ham or grilled cheese sandwiches, plates of pork and beans, and *hot dogs steamés* with *patates frites* (French fries or chips) are what satisfy the hunger here. *Casse-croûtes* can be anything from a curbside hot-dog vendor to small cafeterias, but they all have the means—both delicious and inexpensive—to cure a tourist's hunger pangs.

Beer is drunk everywhere in Canada, and the large bre...
companies such as Molson and Labatt make beers similar...
but rather stronger than, the American brands. In addition,
local microbreweries produce a wide range of ales and beers.

Wine is the most common drink with dinner, and though
most of the wine consumed in Canada is imported from Europe, some locally made table wines are also on sale. In
restaurants, clubs, and bars drinks are fairly expensive. If
having wine, best specify a carafe rather than a bottle—this
will bring its price down considerably, and the quality of
open wines is usually quite presentable.

You can buy beer and cider in grocery stores which have licenses to sell them; supermarkets are not licensed. If you are
looking for wines and liquors, you'll find them in grocery
stores and in the stores run by the Québec Liquor Corporation
(Société des Alcools du Québec), a government-run
distributor, dotted around the
city. You can also get excellent wines at the Maison des
Vins, located on Québec
City's place Royale.

Finally, at the end of the
day, if the choice of one of
the above drinks is too difficult to make, you can't go
far wrong with a jigger of
one of the finest whiskeys in
the world—Canadian rye.

***Rest your feet at a sidewalk
café after a long day
of sightseeing.***

Order...

...ve a table	**Nous voulons une table pour... personnes, s'il vous plâit.**
...a set menu?	**Offrez-vous un menu table d'hôte?**
I'd like a/an/some ...	**Je veux un/une/de ...**

beer	**bière**	mineral water	**eau minerale**
bread	**pain**	(effervescent	**(gaseuse)**
butter	**beurre**	napkin	**serviette**
cider	**cidre**	pepper	**poivre**
coffee	**café**	potatoes	**patates,pommes**
dessert	**dessert**		**de terre**
fish	**poisson**	rice	**riz**
fork	**fourchette**	salad	**salade**
fruit	**fruit**	salt	**sel**
glass	**verre**	soup	**soupe, potage**
ice-cream	**crême glacée**	spoon	**cuillère**
ice	**glace**	sugar	**sucre**
knife	**couteau**	syrup (maple)	**sirop (d'érable)**
meat	**viande**	tea	**thé**
menu	**carte**	water (iced)	**eau (glacée)**
milk	**lait**	wine	**vin**

...and Read the Menu

agneau	lamb	**gâteau**	cake
aiglefin	haddock	**homard**	lobster
ail	garlic	**huîtres**	oysters
ananas	pineapple	**huile**	oil
artichaut	artichoke	**jambon**	ham
asperges	asparagus	**laitue**	lettuce
aubergine	eggplant	**langue**	tongue

beurre	butter	**lapin**	rabbit
biftek	beefsteak	**légumes**	vegetables
bleuets	blueberries	**lièvre**	hare
bœuf	beef	**morue**	cod
boulettes	meatballs	**moules**	mussels
brochet	pike	**moutarde**	mustard
canard	duck	**noix**	nuts
caneton	duckling	**nouilles**	noodles
champignons	mushrooms	**œufs**	eggs
chou	cabbage	**oie**	goose
choufleur	cauliflower	**oignons**	onions
citron	lemon	**orignal**	moose
concombre	cucumber	**ouananiche**	landlocked
confiture	preserves		salmon
courge,	zucchini	**ours**	bear
courgette	vegetable	**pamplemousse**	grapefruit
	marrow	**pêches**	peaches
crevettes	shrimp	**poires**	pears
dinde	turkey	**pommes**	apples
doré	pike/perch	**poulet**	chicken
épinards	spinach	**rognons**	kidneys
érable	maple	**saucisse**	sausage
	syrup	**saumon**	salmon
escargot	snails	**tarte**	pie
faisan	pheasant	**tomate**	tomato
fèves	baked beans	**tourtière**	meat-and
flétan	halibut		potato pie
foie	liver	**truite**	trout
fraises	strawberries	**veau**	veal
framboises	raspberries	**venaison**	venison
fromage	cheese		(deer steaks)

INDEX

HANDY TRAVEL TIPS

An A–Z Summary of Practical Information

A

ACCOMMODATION *(hôtel; logement)*

The Québec Department of Tourism, Fish and Game (see TOURIST INFORMATION OFFICES) rates most establishments in the province and publishes these ratings. To do so, it uses a *fleur-de-lys* symbol, instead of stars, to indicate quality (5-6 *fleurs-de-lys* for a luxury hotel, 3-4 for a mid-range one, and 1-2 for a budget establishment). The Montréal Tourist Guide contains a directory to hotels and motels (including several bed-and-breakfast places) in Montréal. It's available from Tourisme Québec, CP 20000, Québec City, Québec, Canada G1K 7X2, tel. 800-363-7777 (toll-free from Canada and the U.S.). It's also stocked at the Infotouriste center on Dorchester Square. Though hotels listed in the directory are required to have prices posted on an official rate card in each room, the government does not control prices.

Luxury hotels. In the large luxury hotels, the price structure is complex. If demand is heavy, full prices are charged; but when business is slack, you may be able to get accommodation at specially advantageous rates. Package tour arrangements booked in advance are often granted very attractive reductions—sometimes up to 30 percent. Weekend discounts and family tariffs are usually also available if you make advance reservations.

Mid-range. Smaller hotels and tourist homes *(maison de logement)* do not normally grant discounts except for groups or longer stays (a week or more), but the rooms, always clean and neat, may be more interesting, and service will be more personal in this type of hotel.

Budget (see also YOUTH HOSTELS). Inexpensive, simple hotels and rooming houses are scattered throughout the city. Rooms may be small, with only a washbasin and bath down the hall, and service

may be minimal, but prices are truly advantageous—about half those of mid-range hotels.

Motels are rated by the same criteria as hotels, and prices are in the same range.

AIRPORTS (*aéroport*)

Montréal is served by two international airports. Doral Airport, 18 km (10 miles) west of downtown Montréal, handles regular scheduled flights, while Mirabel Airport, 58 km (32 miles) north of downtown, accommodates charter and cargo flights.

Bus transportation from both airports to downtown is operated by Aerocar and leaves from the Queen Elizabeth Hotel and the Station Centrale (Voyageur) bus terminus. For information, phone 514-842-2281. Québec City's airport, Sainte-Foy, has a limousine and a bus service to major downtown hotels.

On flights to the U.S.A., passengers go through U.S. Customs as they check in for their flight (and not after they have landed in the U.S.).

Porter!	**Porteur!**
Taxi!	**Taxi!**
Where's the bus for…?	**Où est l'autobus pour…?**

B

BICYCLE RENTAL

Even if downtown Montréal is not the best of places to get round by bicycle, you'll certainly enjoy miles of relatively empty cyclable roads and designated bike paths in the area around Montréal.

You can rent a bike from any of the bicycle stores listed under "Bicycles-Renting" or "Bicyclettes-Location" in the Yellow Pages of the telephone directory.

The Canadian Hostelling Association (see Youth Hostels) organizes cycling tours through the most interesting areas and towns of the Eastern coast down into north Vermont.

C

CAMPING *(camping)*

The Parks branch of the Québec Government operates campgrounds in the province, but there are also numerous private camping areas. Rates depend on the services and facilities offered. Advance reservations are not usually necessary at park campgrounds. Offices are open from 8:30 A.M. to 4:00 P.M. For all further information and prices, write to the Québec Department of Tourism, Fish and Game, 150 Saint Boulevard East, Québec, Que. GIR 4YI; tel.: 418-890-5349.

May we camp here, please?	**Pouvons-nous camper ici, s'il vous plaît?**
We have a tent/ a trailer (caravan).	**Nous avons une tente/ une caravane.**

CAR RENTAL *(location de voitures)* (See also DRIVING)

Car rental agencies have desks at both Dorval and Mirabel airports and also around Dorchester Square. Competition among companies is spirited, and plenty of special offers or package arrangements are available.

Most credit cards are accepted; without a credit card, the customer is required to put down a deposit equivalent to the anticipated total rental cost plus 20 percent. Some firms set a minimum age of 21, others 25.

CIGARETTES, CIGARS, and TOBACCO *(cigarettes; cigares; tabac)*

In Montréal, shops that sell tobacco products are called *tabagies*. Major tobacconists' carry a wide selection of brands of cigarettes, cigars, and pipe tobacco, and it should be possible to find almost anything you want. Cigarettes are also sold at convenience stores called *dépanneurs*. Tobacco products tend to be slightly more expensive in Canada than in the U.S., and slightly less expensive than in Great Britain. Cuban cigars can be purchased here, but can't be brought back to the U.S.

A pack of…	**Un paquet de…**

A box of matches, please	**Une boîte d'allumettes, s'il vous plaît.**
filter tipped/without filter	**avec/sans filtre**

CLIMATE and CLOTHING

Though summer days are apt to be hot, you should have a sweater or jacket for the evening, even in mid-July. In late spring and early autumn, be prepared for cool days and chilly nights. Winter weather doesn't bother most Montréalers because they dress for it: water-proofed leather boots or galoshes are standard footwear for everyone all winter. Fur, leather, or heavy wool overcoats are everyday winter-wear, and only someone who enjoys head colds will forget hat and scarf.

Some clubs, restaurants, and night-spots require men to wear a coat and tie and some disapprove of jeans and running shoes.

The following chart gives average monthly temperatures in Montréal:

	J	F	M	A	M	J	J	A	S	O	N	D
°C	-9	-8	-2	5	13	19	22	20	15	10	3	-5
°F	16	18	29	41	55	67	72	68	59	50	37	23

COMPLAINTS (see also TOURIST INFORMATION OFFICES and POLICE)

The manager of any respectable hotel is always available to put right any customers' complaints. Otherwise, the municipal, provincial, and national tourist offices may be helpful. Québec's provincial tourist office acts rapidly on complaints about any establishment which may have overcharged or given bad service. Taxi companies will also take up any complaints about one of their drivers, but you'll have to know the driver's name and identification number (it will be on display in the cab).

CRIME (See also POLICE)

As in all big cities, precautions should be taken in public places: pickpockets operate in crowded markets, on buses, and in the Métro; never leave objects in view in the car; always lock your hotel room; deposit valuables in the hotel safe.

All in all, Montréal is a relatively safe place to walk around in; naturally, however, single people would do well to avoid run-down areas at night.

CUSTOMS and ENTRY FORMALITIES *(douane)*
(See also Airports)

U.S. citizens must have some type of identification and proof of address (voter registration card, birth certificate, or passport) to show both the Canadian officials when entering and the U.S. officials when returning. A driver's license is not accepted as identification. British subjects and citizens of most Commonwealth and European countries, as well as of Australia and New Zealand, need only a valid passport—no visa—to enter Canada. But you could be asked at customs to show a return ticket and to prove that you have $20–30 for each day of your stay.

The following chart shows what main duty-free items you may take into Canada and, when returning home, into your own country: There's no limit to the amount of currency that can be imported or exported without declaration.

Into	Cigarettes		Cigars		Tobacco	Liquor		Wine
Canada	200	and	50	and	1 kg	1.1*l*	or	1.1*l*
Australia	200	or	250*g*	or	250*g*	1*l*	or	1*l*
Eire	200	or	50	or	250*g*	1*l*	and	2*l*
N. Zealand	200	or	50	or	250*g*	1.1*l*	and	4.5*l*
S. Africa	400	and	50	and	250*g*	1*l*	and	2*l*
U.K.	200	or	50	or	250*g*	1*l*	and	2*l*
U.S.A.	200	and	100	and	*	1*l*	or	1*l*

* a reasonable amount

I've nothing to declare.	**Je n'ai rien declarer.**
It's for personal use.	**C'est pour mon usage personnel.**

D

DRIVING in CANADA (See also Tourist Information Offices)

U.S. visitors taking their cars into Canada will need: a valid U.S. driver's license; car registration papers; Canadian Non-Resident Interprovince Motor Vehicle Liability Insurance Card or evidence of sufficient insurance coverage to conform with local laws (available from your insurance agent).

Cars registered in the United States can be brought into Canada by the owner or other authorized driver for up to a year by filling out a form at the border. U.S. auto insurance is usually valid in Canada; if in doubt, consult your agent. Note that if you rent a car in the U.S. to drive to Canada, at the border you'll have to show the rental contract, which must state that the car is intended for use in both Canada and the U.S.

European visitors taking their car to Canada will need: a valid driving license; car registration papers; third-party insurance (though comprehensive is strongly advised).

For temporary importation of your car (up to six months), no special customs documents are necessary. But after that, you'll have to pass the Canadian driving test.

Driving conditions. Regulations are similar to those in the U.S.: drive on the right, pass on the left, yield right of way to vehicles coming from your right at unmarked intersections. Roads in the province of Québec are generally good, with enough highway markers and directional signs to make finding your way easy. Nearly all road signs are in French only. Montréal is well served by *autoroutes* (superhighways, motorways) from the New York border, from the Eastern Townships, from Québec City, and from the Laurentians, as well as several others. Maximum speed on expressways is 100 km/h (60 mph), on normal country roads 90 km/h (56 mph), inside towns 50 km/h (30 mph), and in school districts 30 km/h (20 mph). The use of seat belts is obligatory in the province of Québec.

Montréal

Driving in Montréal. There are more than two million cars in Québec. Montréal gets off to a sluggish start in the morning, but around noon all those cars seem to seek parking space in the same street.

The general rule for driving in Montréal is: Take care. Look out for other cars; they won't look out for you. Beware of strange turning habits, swerving from lane to lane, and drag-strip starts when the traffic light changes to green. In Montréal, driving is fast, spirited— and dangerous.

Parking. Street parking is regulated by French-language signs. Private parking lots (*terrains de stationnement*) are expensive; municipal parking lots more reasonably priced, but crowded. Most business districts have parking meters. Tow-away zones are called *zones de remorquage/touage*. Never park in front of a fire hydrant.

Drinking and driving. The police have the legal right to put you through a breath-analysis test. If the alcohol content is above 0.08 percent, you're in trouble.

Breakdowns. You'll hardly ever have any problem in locating a garage and spare parts to fix your car, whatever the make. In the city the tourist office, Infotouriste, on Dorchester Square near Metcalfe, will help you to find a garage. The *autoroutes* are patrolled by cars.

Fuel and oil. There are plenty of filling stations (*postes d'essence*) throughout Québec. Gasoline (*essence*) comes in three types: regular (*ordinaire*), unleaded (*sans plomb*) and premium unleaded (*premium/super*). Note that Québec has many self-service gas stations (*libre-service*), and if you want to have an attendant fill the tank, check the oil, and clean the windshield, look for a station with the sign *essence avec service* (gasoline with service).

Road signs. Most road signs are in French only or are self-explanatory symbols. Here are the most common written ones:

Arrêt	Stop
Attention	Caution
Cédez le passage	Yield

Defense de stationner	No parking
Ecole/Ecoliers	School /Students
Lentement	Slow
Piétons	Pedestrians
Réparations	Road work
Sortie de camions	Truck/lorry exit
Stationnement	Parking
(international) driving license	permis de conduire (international)
car registration papers	les papiers du véhicule (carte guise)
insurance card	certificat d'assurance
Are we on the road to…?	**Sommes-nous sur la route de…?**
Fill the tank, please.	**Faites le plein, s'il vous plaît.**
regular/premium	**ordinaire/super**
Check the oil/tires/ battery	**Vérifiez l'huile/les pneus/ la batterie**
I've had a breakdown.	**J'ai eu une panne.**
There's been an accident.	**Il y a eu un accident.**

E

ELECTRIC CURRENT

The current is the same as in the U.S.A.—110–120-volt, 60-cycle AC. Plugs are the standard two flat-prong American type, so Europeans should buy a plug adapter before they leave for Canada.

an adapter (transformer)	**un adaptateur (transformateur)**
a battery	**une batterie**

EMBASSIES and CONSULATES

In Montréal. American Consulate-General: 1155 rue St-Alexandre, Montréal; tel.: 514-398-9695. Hours: 8:30 A.M. to 2:00 P.M., Monday through Friday. British Trade Commission and Information service: 1155 University Street, suite 901, Montréal; tel.: 514-866-5863.

Montréal

Hours: 9:00 A.M. to 12:30 P.M. and from 2:00 to 4:30 P.M., Monday through Friday.

In Québec City. American Consulate-General: 2 place Terrasse Dufferin, Québec; tel.: 418-692-2095. Hours: 8:30 A.M. to 5:00 P.M., Monday through Friday.

Apart from the consulates listed above, the principal embassies of the U.S., Britain, Ireland, Australia, New Zealand, and South Africa are to be found in Ottawa.

EMERGENCIES

One central number handles all emergency calls, to police, fire, and ambulance services: Dial 911.

Additional numbers for assistance.

Social Services: 527-1375

Distress Centre: 935-1101

Poison Control Centre: 1-800-463-5060

The second page of the White Pages has a complete list of emergency phone numbers.

G

GETTING THERE

Because of the complexity and variability of the many fares, you should ask the advice of an informed travel agent well before your departure.

From the United States and Canada

By air. There are non-stop flights from major Canadian and U.S. cities such as Winnipeg, Ottawa, Boston, Chicago, Miami, and New York, as well as daily direct flights with one or two stops from certain other major cities.

Excursion fares with savings up to 20% are available from most U.S. cities.

By rail. Coach rail fare is cheaper than air fare, especially if you buy a ticket for off-peak dates when rates are reduced. The *Adirondack* is the day train between New York City and Montréal. Amtrak also offers a day train from Washington, D.C. to Montréal. The *Maple Leaf* operates during the day between New York City and Toronto. From the Northwest the best train connections are made by going north and taking the transcontinental *Canadian* from Vancouver.

By bus. Even less expensive than the train, bus service is available from all parts of the United States to Montréal. The main company, Greyhound/Trailways, Inc., has frequent service to New York City with direct daily connections to Montréal, a nine-hour trip. From Boston, Vermont Transit has daily buses to Montréal that takes about eight hours.

By car. Highways to Montréal are good from anywhere in the U.S. and Canada. From the northern or western U.S., the Trans-Canada Highway (Autoroute 17) provides an introduction to Canadian scenery if you have some extra time. Otherwise interstate highways through Chicago and Detroit link up with Canada's routes 401 and 20, which skirt Lakes Erie and Ontario and lead directly to Montréal. The major route from New York State and the Atlantic region is Interstate 87, which becomes Autoroute 15 at the Québec border. New Englanders can use Interstates 89 or 91 to connect with the Canadian highways leading to Montréal.

From the United Kingdom

By air. Scheduled flights leave London daily and Glasgow several times a week. There is a wide range of fares applying to Montréal flights, dependent upon length of stay, how long in advance you can book your ticket, and the normal seasonal variations in prices. July to September is the high season.

Most package tours take in Montréal along with other tourist areas. Tour operators use Advance Booking Charter (ABC) fares and add an organized package holiday. Charter flights from London also use ABC fares; book at least 21 days prior to departure,

round-trip only (travel to one Canadian city and return from another is permissible). There is a vast range of fly-drive packages and other package tours.

From Australia, New Zealand, and South Africa

Australia. Regular flights leave from Sydney with connections in Vancouver or Los Angeles. Package deals run by airlines are sometimes available, and excursion fares or APEX are advantageous.

New Zealand. Daily air services leave for Montréal from Auckland with connections in Los Angeles. There are APEX and Point-to-Point fares available.

South Africa. All scheduled flights leave from Johannesburg with connections in Europe. Many types of package deals are offered by different airlines, and APEX and Excursion fares are also obtainable.

GUIDES and TOURS *(guide)*

A pleasant way to take the tour is in a *calèche* (horse-drawn carriage). Some *calèche* drivers and taxi drivers are licensed city guides and will show you Montréal. Ask for a driver in place d'Armes in Vieux-Montréal, or on Mont Royal near Lac des Castors. Private guide service, paid by the hour, is also available at a similar fee. Contact the tourist office in Dorchester Square (see TOURIST INFORMATION OFFICES) for help in locating a guide.

LANGUAGE

Approximately two-thirds of the city's inhabitants speak French as their mother tongue. Many French-speakers know English, or are even fully bilingual. Because French and English live so closely together in Montréal, a good many words pass from one language to the other and vice-versa: *autoroute* has come into the English vocabulary for superhighway/motorway, while "hot dog" has replaced the French word *saucisse*.

Québec French as spoken on radio and TV is, of course, fully comprehensible to a Parisian, except for a few local word substitutions (*breuvages* instead of *boissons*, beverages), but the working man's accent and dialect *joual* is as far from Parisian French as Cockney is from the Queen's English.

Do you speak English?	**Parlez-vous anglais?**
Good morning/Good day	**Bonjour**
Please	**S'il vous plaît**
Thank you	**Merci**
You're welcome	**Bienvenue**

LAUNDRY and DRY-CLEANING *(blanchissage; nettoyage à sec)*

All hotels will arrange to have laundry done on weekdays, often with same-day service, and some even provide irons and drying lines in the bathroom if you prefer to do your own laundry.

Some Chinese hand laundries are located in the Chinatown district (*quartier chinois*), centred on Clark and La Gauchetière streets, and coin-operated laundromats (*buanderie*) may be found throughout the city.

When will it be ready?	**Quand est-ce que ce sera prêt?**
I must have this for tomorrow morning.	**Il me le faut pour demain matin.**

LOST PROPERTY *(objets trouvés)*

The "lost articles" office for the Métro and city buses is in the Pie IX Métro station; open from 9:00 A.M. to 5:00 P.M., Monday through Friday (tel.: 514-280-4637). Otherwise contact the police, tel. 911.

If your child wanders off in an underground shopping area, the shopkeeper will help you to find him.

I've lost my child/wallet/ handbag/passport.	**J'ai perdu mon enfant/porte-feuille/sac à main/passeport.**

M

MAPS (See also Tourist Information Offices)

Good, detailed maps (*plan*) of downtown Montréal, Vieux-Montréal, and the Montréal urban community, as well as an excellent road map (*carte routière*) of the province, are available from the Québec Department of Tourism, Fish and Game office, or from Infotouriste.

a street plan of… **un plan de…**

a road map of this region **une carte routière de cette region**

MEDICAL CARE (See also Emergencies)

Large hotels have a nurse on duty and a doctor on call at all times. Doctors' fees and hospital care tend to be rather expensive, so you should make sure that your health insurance or health care plan will cover expenses should you become ill in Canada. Alternatively, ask your insurance representative, automobile association, or travel agent for details of special travel insurance policies. Visitors to Canada may also obtain health insurance coverage from the Ontario Blue Cross, a non-profit organization. Details of the plans and application forms may be obtained directly from: Ontario Blue Cross, 185 West Mall, Box 2000; Etobicoke, Ontario M9C5P1; tel. 800-884-7471.

Drugstores and chemists' shops (*pharmacie*) have long opening hours, usually from 9:00 A.M. to 9:00 P.M., with many pharmacies open until midnight. Pharmaprix (5122 Côte-des-Nieges, tel. 514-738-8464) is open 24 hours. Consulates and tourist offices can provide lists of recommended doctors and dentists.

I need a doctor/dentist. **Il me faut un médecin/dentiste.**

MEETING PEOPLE

Language is a hot political issue, and should be taken seriously. If you do speak some French, it's really worth doing so with all French Canadians. You may switch to English after a while, but you'll have demonstrated that you did not take their speaking English for granted.

A word on ways to broach a conversation: when asking a stranger for directions, start with *Pardon* (Excuse me) to pave the way; *Bonjour* (Good morning/Good day) is appreciated at all times of the day (Montréalers will even tend to say *Bonjour* when leaving a shop, rather than standard French *Au revoir*).

MONEY MATTERS

Currency: The Canadian dollar is printed in both English and French; all bills are the same size, but the several denominations are of different colours. Bills range from 5, 10, 20, 50, 100, 500, and 1,000 dollars. Coins come in 1, 5, 10, 25, and 50 cents, 1 dollar (known as the "looney") and 2 dollar (known as the "twoney").

Banking hours: Most banks are open from 10:00 A.M. to 4:00 P.M. Monday through Friday, and several have branches that open earlier or close later. Some are also open on Saturday. Many branches give 24-hour access to ATMs.

Changing money: European and other currencies are not easy to exchange outside major centers; try and have as much as possible of your money (cash, travellers' checks, etc.) in Canadian (or U.S.) dollars. Money can also be obtained from ATMs throughout the city. For information on locations, call 800-424-7787 for Cirrus or 800-843-7587 for Plus.

Currency-exchange offices at Dorval Airport are open from 6:00 A.M. to 11:00 P.M. Those at Mirabel are open for all incoming flights. When changing money or travellers' checks, ask for 5- to 20-dollar bills, which are accepted everywhere, as some establishments may not accept larger banknotes.

I want to change some **Je veux changer des dollars**
 U.S. dollars/pounds. **américains/livres sterling.**

Credit cards and travellers' checks *(carte de credit; chèque de voyage):* The major credit cards and travelers checks issued in Canadian or U.S. dollars are accepted throughout Canada at banks, hotels, restaurants, most shops, and gas stations. Users of various cred-

it cards can also get cash in Canadian dollars round the clock, from widely available dispensers. For transactions with credit cards or travellers' checks, it's useful to have some form of identification.

Can I pay with this credit card?	**Est-ce que je peux payer avec cette carte de crèdit?**
Do you accept travellers' checks?	**Acceptez-vous les chèques de voyage?**

PLANNING YOUR BUDGET

To give you an idea of what to expect, here is a list of average prices in U.S. dollars. They can only be approximate, however, as inflation creeps relentlessly up. Bear in mind that in addition to provincial sales tax, a 7% federal sales tax (GST) applies to all goods and services bought in Canada.

Airports. Aerocar bus from Dorval to downtown $8.50, taxi $22.

Car rental. Subcompact $38 per day (with 200 free kilometers), 15¢ per extra km, $193 per week (with up to 1,400 free km). Station wagons $60 per day (with 100 km free), 20¢ per extra km, $329 per week (with up to 1,000 km free). Cut-rate rental: $17 per day, $179 per week. Prices exclude tax and insurance.

Entertainment. Nightclub/discotheque up to $10, cinema $8.

Hotels and motels (double room per night). Luxury (6 *fleurs-de-lys*) $115–200 and up, comfortable (3 *fleurs-de-lys*) $85–100 and up, motels and inexpensive hotels $40–80.

Intercity buses. Montréal-Québec City (round-trip day excursion) $38–55, 10-day ticket $38.55 (tel. 514-842-2281). Montréal–Mont Tremblant (round-trip) $32.80. Montréal–Ottawa return $33 (valid one year), one-day excursion fare $22.90. Montréal–Toronto one way $35.95, 10-day excursion fare $55.90, one-day excursion fare $54.90.

Food and Drink. Breakfast from $5, lunch $5–15, dinner $12–50, coffee/soft drinks $1–2, cappuccino $2.00, bottle of wine $15–30,

beer $3.60 and up, cocktails $5.50 and up.

Public transportation (city of Montréal). Bus/metro ticket $1.30, 1-day tourist pass $3.55, 3-day tourist pass $8.50.

Taxis. Most short rides cost about $3.50 U.S.

Trains. Montréal–Québec, one way, $32, Montréal–Ottawa $26, Montréal–Toronto $65 (tel. 514-871-1331).

NEWSPAPERS and MAGAZINES *(journal; revue)*

Newsstands in large hotels carry the major French-language Montréal papers as well as the English-language *Gazette*, the *Globe and Mail* national editions, and often the *New York Times*. The same newsstands may provide you with the local morning paper of your choice for free if you fill out an order slip (ask at the reception). Magazines and other newspapers are sometimes carried by hotel newsstands, or can be found in Central Station under the Queen Elizabeth hotel. A large stand with a very wide-ranging selection is Metropolitan News at 1109 Cypress (off the west side of Dorchester Square); tel. 514-866-9227. It's open from 8:30 A.M. to 6:30 P.M. every day. Foreign newspapers usually arrive in Montréal the same day, the London and Paris ones often by mid-morning.

PETS

Cats and dogs entering from the U.S. must be accompanied by a certificate signed by a vet certifying the animal has been vaccinated against rabies within the preceding 36 months. Pets from other countries may be subject to special regulations, so it's best to check with a Canadian consulate or information service office before you leave home. On return to Great Britain or Ireland, a dog will have to be kept in quarantine for six months; the U.S. reserves the right to quarantine returning animals as well. Some large hotels permit animals,

and may even have special kennels, but it's best to check on their rules in advance.

PHOTOGRAPHY

Purchase and repair of cameras, buying film, or having it developed are all easy in Montréal, though a bit more expensive than in the U.S. Camera shops give the fastest service for developing film, though almost any drugstore will do it for you in a week.

I'd like a film for this camera.	**Je voudrais un film pour cet appareil photo.**
black-and-white film	**film en noir et blanc**
film for colour prints	**film en couleur**
colour-slide film	**film de diapositives**
How long will it take to develop (and print) this film?	**Combien de temps faudra-t-il pour développer (et tirer) ce film?**

POLICE *(police)*

Of the police forces in Québec, the federal RCMP (Royal Canadian Mounted Police) are the most colourful and romantic, but they are rarely seen except when taking part in ceremonies and celebrations. Police duties in Montréal are performed by the municipal MUC (Montréal Urban Community) police force wearing blue uniforms. In addition, a provincial police force, La Sûreté du Québec, in brown uniforms, patrols highways and provides police service in small towns and in the countryside. Police emergency number: 911.

Where's the nearest police station?	**Où se trouve le poste de police le plus proche?**

POST OFFICES *(poste)*

Post offices are located throughout Montréal. For information on opening hours and locations, call the customer service department at 514-344-8822. Postage stamps *(timbre)* can also be bought in many shops, from vending machines, and in hotels. Mail boxes, which are

painted red, are located in the streets, in rail and bus stations, and in hotel lobbies, and times of collection are posted on them.

A stamp for this letter/ postcard, please.	**Un timbre pour cette lettre/ carte postale, s'il vous plaît.**
special delivery	**par express**
air mail	**par avion**

PUBLIC HOLIDAYS *(jour férié)*

When a holiday falls on a Sunday, the following Monday is often observed as the holiday. These holidays are the official ones, when all government offices and most businesses are closed (although nearly all businesses are open on Remembrance Day):

1 January	**Jour de l'An**	New Year's Day
1 July	**Fête du Canada**	Canada Day
11 November	**Jour de l'Armistice**	Remembrance Day
25 December	**Jour de Noël**	Christmas Day
26 December	**Après-Noël**	Boxing Day

In addition, Québecois observe at least in part:

24 June **Fête de la Saint-Jean-Baptiste**

St. John the Baptist's Day (Patron Saint of French Canadians).

Moveable dates:

	Vendredi Saint	Good Friday
	Lundi de Pâques	Easter Monday
Monday before 25 May	**Fête de Dollard ou de la Reine**	Fête de Dollard or Victoria Day
First Monday in September	**Fête du travail**	Labour Day
Second Monday in October	**Jour action de grâce**	Thanksgiving Day

R

RADIO and TV *(radio; télévision)*

Montréal has nine English-language radio stations (four AM, five FM) and 18 French (seven AM, eleven FM) as well as two multi-lingual stations (one AM, the other FM) that serve the city's ethnic minorities. Six television stations, two English and four French, serve the Montréal area: channel 2 and 6 are run by the Canadian Broadcasting Corporation (Radio-Canada), and other channels are private commercial stations. Full details of weekly broadcasting schedules are published as a supplement in Saturday newspapers. Cable television, widely available, provides nearly 40 channels, including several from the U.S.

RELIGION *(messe; culte)*

Québec is a predominantly Roman-Catholic province. Besides the many Catholic churches, Montréal has churches of all major denominations and some of the smaller ones as well. The city's Jewish temples represent the Reform, Conservative, and Orthodox rites. A mosque in Ville Saint-Laurent is the focal point for worship by the city's Muslims.

T

TELEPHONE *(téléphone)*

The telephone company, Bell Canada, is similar to the U.S. System, so service and procedures are virtually identical in both countries. Directions for pay-phone use are posted beside phones in booths in both French and English. The directories *(annuaire des téléphones)* are White Pages *(Pages Blanches)* containing private, public, and government subscribers' numbers, and a list of sample long-distance rates; and Yellow Pages *(Pages Jaunes)*, businesses, services, and organizations grouped by type, product, or service. Long-distance calls, which can be dialed direct, will be station-to-station calls

unless you signal the operator (dial zero) and specify person-to-person (*appel de personne-à-personne*) or collect (*appel à frais virés*). For overseas calls (*appel à outre-mer*), dial 0 (zero) and ask for the country you wish to call.

TIME DIFFERENCES

Most of Québec province, including Montréal and Québec City, is on Eastern Time, the same as New York and the entire U.S. east coast. Regions farther east (the Gaspé Peninsula, Nova Scotia, New Brunswick) are on Atlantic Time; Newfoundland has its own Newfoundland Time, one half-hour earlier than Atlantic. To the west of Québec are four more time zones covering the rest of Canada and the U.S.A.: Central, Mountain, Pacific, and Yukon. From the first Sunday in April until the last Saturday in October, clocks are advanced one hour to Daylight Saving Time.

Vancouver/Los Angeles	9 A.M.
Winnipeg/Chicago	11 A.M.
New York/Montréal	noon
Halifax	1 P.M.
St. John's/London	1:30 P.M.
What time is it please?	**Quelle heure est-il, s'il vous plaît?**

TIPPING

Since a service charge is normally not included in hotel and restaurant bills, tipping is customary. It is also appropriate to give something extra to bellboys, hat-check attendants, etc., for their services. The chart below gives some suggestions as to how much to leave.

Hairdresser/Barber	15%
Maid, per day	$1.50
Porter, per bag	$1
Taxi driver	15%
Tour guide	15% optional
Waiter	15%

Montréal

TOILETS *(toilettes)*

In this bilingual city where more and more signs bear symbols, not words, almost all toilets have the familiar pictographs of a man or a woman, although you may encounter the words *Hommes* (Men) and *Dames* (Ladies). Department stores, rail and bus stations, and many underground complexes have public toilets, but they are few and far between, so take advantage of what you find.

TOURIST INFORMATION OFFICES *(renseignements touristiques)*

The Canadian Government Office of Tourism and the Québec Department of Tourism maintain information offices in many foreign countries. They'll supply you with informative brochures, maps, and hotel guides. Ask for a copy of Montréal's Calendar of Events, a seasonal list published twice a year with information on scheduled art exhibitions, theatre, concerts, sports, and special events.

Some addresses of Québec or Canadian Government offices abroad:

Australia. Canadian Government office of Tourism, 8th floor, AMP Centre, 50 Bridge Street, Sydney 2000; tel.: 231-6522.

Great Britain. Delegation Generale du Québec, 59 Pall Mall, London SW1Y SJH; tel.: 071-930-8314.
Canadian Government Office of Tourism, Canada House, Trafalgar Square, London SW1 Y 5BJ; tel.: 071-258-6600.

U.S.A. Delegation Generale du Québec, 17 W. 50th Street, Rockefeller Center, New York, NY, 10020; tel.: 212-397-0200.
Canadian consulate General, 3 Copley Place, suite 400, Boston, MA 02116; tel.: 617-262-3760 or at Canadian Consulate General, 550 South Hope St., Los Angeles, CA 90071; tel.: 213-346-2701; fax: 213-620-8827. You can also access tourist information via the World Wide Web at the Official Québec Government Tourist Site (www. tourisme.gouv.qc.ca) or the Montréal Official Tourist Info website at (www.tourism-montreal.org).

In Montréal, both the Québec Government and the Montréal Urban Community maintain tourist information offices:

Centre Infotouriste (municipal and provincial) 1001 rue du Square-Dorchester (corner of rue Peel). There is a branch on place Jacques-Cartier in Vieux-Montréal (off rue Notre-Dame). There are also tourist information offices at Dorval and Mirabel airports.

TRANSPORTATION

Transport de la Communauté Urbaine de Montréal (Montréal Urban Community Transit Commission) operates the city's bus and Métro systems, which are attractive, clean, and highly efficient. Tickets for the system can be bought individually, and transfers between the two systems (*correspondance*) are free. However, tickets good for both bus and Métro are also sold at a small discount in books of six (*carnet de billets*) at newsstands and Métro stations.

It's important you know in which direction you are going, because nearly each bus or Métro line has its own stop or platform. The Métro, for instance, is sometimes on two or three levels.

The Métro is modeled on that of Paris, with trains as long as the station platform. When paying to enter the Métro, drop the exact change down the transparent plastic chute in the ticket-seller's booth; if you need change, slip a bill through the hole at the bottom of the booth window. The Métro operates from 5:30 A.M. until 12:30 A.M. (Fridays and Saturdays until 1:00 A.M.). Line 5 always stops at 11:00 P.M.

Bus. When you want to transfer from bus to Métro, the procedure is the following: board at the front of the bus, pay the exact fare, and then ask the driver for a transfer. When you switch to the Métro, insert the transfer in the turnstile slot; another transfer will be issued for you from the automatic dispenser just inside the turnstiles. After your train journey,

you can use this second transfer on a bus; just hand it over to the driver. Buses on Sainte-Catherine and Saint-Denis routes operate every day, 24 hours a day.

Maps of the métro network are found on the station walls. For further information, call 288-6287.

Train *(train)*. VIA Rail Canada, an Amtrak-like corporation, operates all passenger services in Canada, using lines, stations, and equipment of what was once Canadian National and Canadian Pacific railroads. For information and schedules, call 514-871-1331.

Note: Canrailpasses are available for Europeans, giving unlimited rail travel for periods of 8, 15, 22, or 30 days at a flat rate. They must be bought in Europe before departure. Ask your travel agent for details.

Taxis *(taxi)*. Several private taxi fleets serve Montréal. The automobiles used are usually American-style sedans, clearly marked as taxis. You'll find taxi stands near the big hotels, in squares, and at railroad and bus terminals. Your hotel will have a list of telephone numbers if you prefer to ring for one. All cabs are metred, and rates, plus the driver's name and number, are posted in the car.

W

WATER *(eau)*

All tap water is safe to drink. Luxury hotels often have ice-water taps in bathrooms, and most hotels and motels provide ice, usually from an ice-making machine placed in the corridor or stairwell. Well-known brands of Canadian and French mineral water are sold in specialty groceries and in better restaurants.

a bottle of mineral water	**une bouteille d'eau minérale**
carbonated/non-carbonated	**gazeuse/non gazeuse**

WEIGHTS and MEASURES

Length

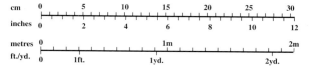

Weight

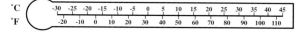

Temperature

Y

YOUTH HOSTELS *(auberge de jeunesse)*

The Canadian Hostelling Association publishes a directory of all the youth hostels in Canada, as well as information on tours, bicycle trips, skiing, and charter flights. They also issue International Membership Cards which are applicable at hostels all over the world. For information on youth hostels in Québec, contact Tourisme Jeunesse, 4545 av. Pierre-de-Coubertin C.P. 1000, Succursale M,.Montréal (Quec), Canada H1V3R2; tel.: 514-252-3117.

The Montréal Youth Hostel is located at 1030 Mackay Street; tel.: 514-934-4639. Information can also be obtained at their website: www.hostellingmontreal.com.

Montréal

SOME USEFUL EXPRESSIONS

yes/no	**oui/non**
please/thank you	**s'il vous plaît/merci**
excuse me	**excusez-moi**
you're welcome	**bienvenue**
where/when/how	**où/quand/comment**
how long/how far	**combien de temps/à quelle distance**
yesterday/today/tomorrow	**hier/aujourd'hui/demain**
day/week/month/year	**jour/semaine/mois/année**
left/right	**gauche/droite**
up/down	**en haut/en bas**
good/bad	**bon/mauvais**
big/small	**grand/petit**
cheap/expensive	**bon marché/cher**
hot/cold	**chaud/froid**
old/new	**vieux/neuf**
open/closed	**ouvert/fermé**
Does anyone here speak English?	**Y a-t-il quelqu'un ici qui parle anglais?**
What does this mean?	**Que signifie ceci?**
I don't understand.	**Je ne comprends pas.**
Please write it down.	**Veuillez me l'écrire, s'il vous plaît.**
Is there an admission charge?	**Y a-t-il des frais d'entrée?**
Waiter!/Waitress!	**Monsieur!/Mademoiselle!**
I'd like...	**J'aimerais...**
How much is that?	**C'est combien?**
Have you something less expensive?	**Avez vous quelque chose de meilleur marché?**
What time is it?	**Quelle heure est-il?**
Help me please.	**Aidez-moi, s'il vous plaît.**
Get a doctor—quickly!	**Un médecin, vite!**

Recommended Hotels

Montréal is a major tourist destination, and provides a wide range of accommodation. July and August remain the busiest months, along with Canadian and American holidays. Be sure to make a reservation well in advance at these times.

Listed below is a selection of hotels in four price categories. As a basic guide we have used the symbols below to indicate prices for a double room with bath, including breakfast:

✪	below C$90
✪✪	C$90–120
✪✪✪	C$120–160
✪✪✪✪	over C$160

Be prepared for two taxes to be added to your hotel bill. Local Montréal government imposes a 6.5% tax on accommodations (TVQ) and federal government imposes a 7% tax for services (TPS). A refund for both taxes is available to foreign visitors, providing the receipts are saved and the appropriate refund form is filed. The prices above do not include these taxes.

*Note that at the end of each listing is a reference to the payment policies for each restaurant: "cash only" means no credit cards are accepted; "major credit cards" means cash or all major credit cards are accepted; and "MC and V only" means only Master Card and Visa are accepted (American Express cards not accepted).

Auberge de la Fontaine ✪✪–✪✪✪ *1301 rue Rachel est, H2J 2K1; Tel. 514-597-0166 or 800-597-0597, fax 514-597-0496.* Colourful rooms and friendly staff really brighten this delightful little hotel in the Plateau Mont-Royal district. Two turn-of-the-century residences have been converted into 21

rooms, with a small, ground-floor kitchen open to guests, who are invited to take what they like (whenever they like) from the snack-filled refrigerator. Some rooms have whirlpool baths and/or private balconies. Rates include breakfast and snacks. Meeting room, 21 rooms. Major credit cards.

Auberge Les Passants du Sans Soucy ✪✪✪✪ *171 rue St-Paul ouest, H2Y 1Z5; Tel. 514-842-2634, fax 514-842-2912.* Charming and romantic, with a lobby that doubles as an art gallery and features a fireplace that is kept burning throughout the winter. Rates include full breakfast in a pleasant breakfast room. 8 rooms, 1 suite. Major credit cards.

Auberge du Vieux-Port ✪✪✪✪ *97 rue de la Commune est, H2Y 1J1; Tel. 514-876-0081, fax 514-876-8923.* The back of this lovely hotel faces rue St-Paul and the front overlooks the busy Vieux-port. This is a historic building that has been renovated and was recently re-opened in 1996. Tasteful interiors; rates include breakfast in the hotels' excellent French restaurant, Les Remparts. Restaurant, adjacent coffee shop. 27 rooms. Major credit cards.

Bonaventure Hilton International ✪✪✪✪ *1 place Bonaventure, H5E 1E4; Tel. 514-878-2332 or 800-267-2575, fax 878-3881.* Located above the place Bonaventure exhibition centre; outdoor pool and gardens, shops, business services, 395 rooms; 3 restaurants. Major credit cards.

La Cantile Suites ✪✪–✪✪✪✪ *1110 rue Sherbrooke ouest (at rue Peel), H3A 1G9; Tel. 514-842-2000 or 800-567-1110, fax 514-844-0328.* Converted apartment house conveniently located in the center of town, close to shopping, restaurants, and nightlife. Beautiful views, rooftop pool (open in summer only), small fitness area, easy access to running trails on Mont-Royal. 226 suites. Major credit cards.

Castel St-Denis ✪ *2099 rue St-Denis, H2X 3K8; Tel. 514-842-9719, fax 514-8438492.* Decent economy hotel located in the Latin Quarter, 2 blocks from the Station Centrale (Terminus Voyageur) bus station. Friendly owner will provide tips for local dining and attractions. 18 rooms.

Le Centre Sheraton ✪✪✪✪ *1201 blvd. René-Lévesque ouest, H3B 2L7; Tel. 514-878-2000 or 800-325-3535, fax 514-878-3958.* Conveniently located between the restaurant-laden area of Ishon and Cresent streets and the downtown business district. The mammoth hotel caters both to business travellers and high-end tourism. Restaurant, 3 bars, indoor pool, beauty salon, health club with sauna and whirlpool. 825 rooms. Major credit cards.

Château Versailles ✪✪–✪✪✪ *1659 rue Sherbrooke ouest, H3H 1E3; Tel. 514-933-3611 or 800-361-3664 (800-361-7199 in Canada), fax 514-933-3611.* This elaborate hotel complex includes a row of four converted mansions decorated in grand style to comprise the Château, and an annex to the original four structures, a converted apartment hotel across the street now known as La Tour Versailles. La Tour contains the Champs-Elysées, a fine French restaurant. Restaurant, breakfast room (in Château). 70 rooms in Château; 105 rooms, 2 suites in La Tour. Major credit cards.

Delta Montréal ✪✪✪ *475 av. President-Kennedy; Tel. 514-286-1986 or 800-268-1133, fax 514-284-4306.* Boasts an expansive lobby and large rooms. Excellent exercise and pool facilities. Most rooms have a view of either the mountain or downtown. 2 restaurants, bar, indoor and outdoor pools, sauna, aerobics, health club, squash courts, business services. 453 rooms, 10 suites. Major credit cards.

First Courtyard Marriott Montréal ✪✪–✪✪✪✪ *410 rue Sherbrooke ouest (near rue Mansfield), H3A 1B3; Tel. 514-844-*

8851 or 800-449-6544, fax 514-844-0328. Primarily a corporate hotel. Small fitness center, indoor pool, 5 banquet rooms, and full banquet services. 180 rooms. Major credit cards.

Holiday Inn Montréal Midtown ✪✪✪–✪✪✪✪ *420 rue Sherbrooke ouest (at av. du Parc), H3A 1B4; Tel. 514-842-6111 or 800-387-3042, fax 514-842-9381.* Summer and family packages available. Indoor pool with lifeguard on duty, well-equipped fitness centre, massage centre, hair salon, coffee shop. 485 rooms. Major credit cards.

Hostelling Montréal ✪ *1030 rue MacKay, H3G 2H1; Tel. 514-843-3317, fax 514-934-3251.* Well-run hostel in the heart of downtown, with kitchen facilities and lockers for valuables. Same-sex dorms sleep 4, 6, or 10 people. Some rooms available for couples and families. Members pay $17.50 for a bed, nonmembers $22. Coin laundry. 263 beds. MC and V only.

Hotel Inter-Continental Montréal ✪✪✪–✪✪✪✪ *360 rue St-antoine ouest, H2Y 3X4; Tel. 514-987-9900 or 800-327-0200 (800-361-3600 in the U.S. and Canada), fax 514-847-8550.* Located in the Montréal World Trade Center. Large, modern rooms with views of downtown or Vieux-Montréal and the waterfront; integrates historic Nordheimer Building for banquets and other special events. 3 restaurants, bar, indoor pool, sauna, health club, massage, steam room. 334 rooms, 23 suites. Major credit cards.

Hôtel Lord Berri ✪✪ *1199 rue Berri, H2L 4C6; Tel. 514-845-9236 or 888-363-0363, fax 514-849-9855.* Modest hotel near restaurants and night spots of rue St-Denis. Features good Italian restaurant, Il Cavaliere. Meeting rooms, small exercise room. 154 rooms. Major credit cards.

Hôtel de la Montagne ✪✪✪ *1430 rue de la Montagne, H3G 1Z5; Tel. 514-288-5656 or 800-361-6262, fax 514-288-*

9658. Ostentatious interior, rooftop terrace, and tunnel connecting hotel to Thursdays, a popular restaurant and nightclub. 2 restaurants, piano bar, outdoor pool. 134 rooms. Major credit cards.

Hôtel du Parc ✪✪–✪✪✪ *3625 av. du Parc, H2X 3P8; Tel. 514-288-6666 or 800-363-0735, fax 514-288-2469.* Overlooks the Parc du Mont-Royal, 5 minutes' walk from the McGill University campus. Large rooms, efficient staff. Restaurant, bar, café, indoor pool, tennis and squash courts, access to LaCité health club. 439 rooms, 20 suites.

Hôtel Radisson des Gouverneurs de Montréal ✪✪✪–✪✪✪✪ *777 rue University, H3C 3Z7; Tel. 514-879-1370 or 800-333-3333, fax 514-931-3233.* Located on the western edge of Vieux-Montréal near place Bonaventure, this hotel tends to cater to (and is popular for) conventions. Shopping arcade on underground level, revolving restaurant on top, and 3-storey atrium reception area in-between. 2 restaurants, bar, indoor pool, steam room, health club. 550 rooms, 25 suites.

Hôtel Wyndham Montréal ✪✪✪ *4 Complexe Desjardins, C.P. 130, H5B 1E5; Tel. 514-285-1450 or 800-361-8234, fax 514-285-1243.* Modern luxury hotel (formerly the Hôtel Complexe Desjardins) built above Complexe Desjardins, the spectacular mall in the heart of the underground city. Restaurant, piano bar, indoor pool. 572 rooms, 28 suites. Major credit cards.

Loews Hôtel Vogue aaaa *1425 rue de la Montagne, H3G 1Z3; Tel. 514-285-5555 or 800-465-6654; fax 514-849-8903.* Directly across the street from Ogilvy department store. Bathrooms have whirlpool baths; television, phone. L'Opera Bar looks out from the lobby onto rue de la Montagne. 125 rooms, 14 suites. Major credit cards.

Le Marriott Château Champlain ✪✪✪ *1050 rue de la Gauchetière, H3B 4C9; Tel. 514-878-9000 or 800-200-5909, fax 878-6761.* Located at the southern end of place du Canada. Elegant furnishings; connected by tunnel to Bonaventre Métro station and place Ville-Marie. Restaurant, bar, indoor pool, sauna, fully equipped gym. 611 rooms, 33 suites. Major credit cards.

Les Passants du Sans Soucy ✪✪–✪✪✪✪ *171 rue St-Paul ouest, H2Y 1Z5; Tel. 514-842-2634; fax 514-842-2912.* Refreshing bed-and-breakfast set in a house from 1723 in the heart of Vieux-Montréal. Homey details and gracious, pleasant owners make for a delightful stay. Rates include breakfast. 9 rooms. Major credit cards.

La Reine (Queen Elizabeth) ✪✪✪–✪✪✪✪ *900 blvd. René-Lévesque ouest; Tel. 514-954-2256 or 800-441-1414; fax 514-954-2256.* Montréal's largest hotel, located above VIA Rail's Gare Centrale. There is convenient tunnel access to place Ville-Marie and place Bonaventure. Fine dining featured in Le Beaver Club (see page 136). Modest health club, beauty salon, boutiques. 1,062 rooms, 60 suites. Major credit cards.

Ritz-Carlton Kempinski ✪✪✪✪ *1228 rue de Sherbrooke ouest, H3G 1H6; Tel. 514-842-4212 or 800-363-0366; fax 514-842-3383.* Attentive service, delightful atmosphere, and fine amenities abound at this grand, luxurious hotel. Some suites have working fireplaces. Restaurant, bar, piano bar, barbershop. Café de Paris offers elegant dining. 185 rooms, 45 suites. Major credit cards.

Taj Mahal ✪ *1600 rue St-Hubert, H2L 3Z3; Tel. 514-849-3214, fax 514-849-9812.* Located conveniently adjacent to the Station Centrale (Terminus Voyageur) bus station; also near Berri-UQAM Métro station. Large, clean rooms and friendly service. 147 rooms. Major credit cards.

Travelodge Montréal Centre ✪ *50 blvd. René-Lévesque ouest (at rue Clark); Tel. 514-874-9090 or 800-363-6535, fax 514-874-0907*. Nondescript economy hotel located next to the Complexe Desjardins. Small but pleasant rooms, coffee-makers in all rooms. Dining room (breakfast and dinner only) and bar. 242 rooms. Major credit cards.

Le Westin Mont-Royal ✪✪✪✪ *1050 rue Sherbrooke ouest, H3A 2R6; Tel. 800-228-3000 or 514-284-1110, fax 514-845-3025*. Formerly the Four Seasons, this hotel is a mainstay of elegant accommodation in Montréal. The two restaurants, Zen, an upscale Chinese eatery, and their new dining room, Opus II, offer a choice in fine dining. Well-equipped health club, outdoor pool (open year-round), sauna, whirlpool. 300 rooms, 27 suites. Major credit cards.

YMCA ✪ *1450 rue Stanley, H3A 2W6; Tel. 514-849-8393, fax 514-849-8017*. Huge complex offers accommodation to men, women, and their families. Most rooms have telephones and colour televisions. Guest have free access to a weight-training room, indoor pool, saunas, squash courts, and running track. Inexpensive cafeteria serves all meals except weekend dinners. Advance reservations are recommended. 331 rooms. Major credit cards.

YWCA ✪ *1355 blvd. René-Lévesque ouest (at rue Crescent), H3G 1T3; Tel. 514-866-9941, fax 514-861-1603*. Accommodation for women only and their children (girls any age, boys up to age 8). Guests have free access to a weight-training room, indoor pool, sauna, and fitness classes. 150 rooms. MC and V only.

Recommended Restaurants

Montréal has more than 4,500 restaurants that now offer any kind of international cuisine you could desire. Previously, Montréal establishments were strictly French, but with the recession of the early 1990s and the growing number of immigrants from all corners of the world who have brought their own cuisines with them, choices in dining have vastly expanded. As a result, it can be totally overwhelming trying to decide on a restaurant—from Moroccan, Mexican, and Créole to Szechuan, Japanese, and Vietnamese. We have tried, in this section, to make the selection easier for you, whether it's a quick meal you are looking for, or a luxurious dining experience.

The listed restaurants are categorized according to city districts and use the following price system in Canadian dollars:

✪	under C$10
✪✪	C$10–$20
✪✪✪	C$20–$30
✪✪✪✪	over C$30

*Note that at the end of each listing is a reference to the payment policies for each restaurant: "cash only" means no credit cards are accepted; "major credit cards" means cash or all major credit cards are accepted; and "MC and V only" means only Master Card and Visa are accepted (American Express cards not accepted).

Downtown

L'Actuel ✪ *1194 rue Peel (on Square Dorchester), Tel. 514-866-1537.* A Belgian restaurant specializing in mussels and double-fried potatoes and offering very large helpings. Downstairs bar. Beautiful view of the square in dining room. Major credit cards.

Le Beaver Club ✪✪✪✪ *in Hôtel La Reine, 900 René-Lévesque ouest, Tel. 514-861-3511.* This large, ornate restaurant (that gets

its name from a social club established in 1785) is decorated with taxidermy, stained glass, and beautifully carved wood panels. Music on Saturdays, beginning at 7:30 P.M. for dancing. Jackets are required for male patrons. Reservations recommended. Major credit cards.

Ben's ✪ *990 blvd. de Maisonneuve ouest, Tel. 514-844-1000.* Deli-style sandwiches including the "Big Ben Sandwich"— with Montréal's version of corned beef. 50s decor enhances the deli atmosphere. Full bar available. MC and V only.

Bleu Marin ✪✪✪ *1437-A rue Crescent, Tel. 514-847-1123.* Specializing in seafood, Italian-style. Main course specials include fillet of sea bass baked with lemon, wine, and capers. Major credit cards.

Bocca d'Oro ✪✪✪ *1448 rue St-Mathieu, Tel. 514-933-8414, Tel. 514-878-9888.* Serves a large variety of pasta dishes, from plain spaghetti to spinach ravioli stuffed with salmon and caviar. Excellent service. Major credit cards.

Chez Chine ✪✪ *99 Niger West, Tel. 514-878-9888.* This restaurant offers an enchanted view of a miniature lake and a wonderful assortment of stir-fry and shark-fin specialties. Major credit cards.

Chez Pauzé ✪✪✪ *1657 Ste-Catherine ouest (near rue Bishop), Tel. 514-932-6118.* Once Montréal's oldest fish house, this restaurant specializes in everything from surf 'n' turf to Arctic chat. In the summer months sit out on the terrace. Major credit cards.

Le Commensal ✪ *1204 av. McGill College (at rue Ste-Catherine), Tel. 514-871-1480.* A self-service buffet restaurant providing a nice view on the second floor. You pay the cashier by weight. No tipping. Vegetarian. Major credit cards.

Les Halles ✪✪✪✪ *1450 rue Crescent (between rue Ste-Catherine and blvd. de Maisonneuve), Tel. 514-844-2328.*

Considered one of the best French restaurants in Montréal; be prepared for high prices. It manages to keep its bistro-style atmosphere in spite of the cost. The menu includes beef, lamb, seafood, and game dishes, served in huge portions. Major credit cards.

Katsura ✪-✪✪ *2170 rue de la Montagne, Tel. 514-849-1172*. The restaurant attributed to introducing sushi to Montréal, offering both Western and traditional Japanese dining rooms. Sushi bar in back room. Reservations recommended. Major credit cards.

Magnan ✪-✪✪ *2602 rue St-Patrick, Tel. 514-935-9647*. A popular sports-oriented tavern that attracts both working-class and executive clientele. They serve excellent roast beef, local beer on tap, and steaks ranging from 6 to 22 ounces. Reservations required. Major credit cards.

La Maison Kam Fung ✪ *1008 rue Clark, Tel. 514-878-2888*. On weekends and holidays Kam Fung's offers a special mid-day *dim sum* feast. They serve every kind of dumpling imaginable. For dinner fare, try the seafood kept live and cooked to order, or one of their many Cantonese and Szechuan specialties. Major credit cards.

Le 9e ✪ *677 rue Ste-Catherine, Tel. 514-284-8421*. The "Neuvième" originally acquired its name from its location, the ninth floor of a department store, back in 1931. The decor copies that of a dining room on the ocean liner *Ile de France*. This is very light fare, soups, and salads, although it now offers a tantalizing pasta table.

Pizzaiole ✪✪ *1446-A rue Crescent, Tel. 514-845-4158*. Renowned for the first wood-fired pizzas in Montréal; you can choose from 30 possible combinations. Their *calzone* is a nice alternative to pizza. Major credit cards.

La Sila ✪ *2040 rue St-Denis, Tel. 514-844-5083*. Redecoration has made this dark Italian restaurant much brighter; its wonder-

ful terrace is to be enjoyed in the summer months. Offers home-made pastas. Free parking. Reservations recommended. Major credit cards.

Sir Winston Churchill ✪ *1459 rue Crescent (between blvd. de Maisonneuve and rue st-Catherine), Tel. 514-288-3814.* If it's burgers and beer at an affordable price you're after, stop by this English-style pub. Attracts a young, single crowd during the evenings. Major credit cards.

Le Taj ✪ *2077 rue Stanley, Tel. 514-845-9015.* Northern Indian cuisine with an open tandoor oven is offered at this flavourful, reasonable, and often quiet restaurant. Major credit cards.

Vieux-Montréal

Le Bourlingueur ✪✪ *363 St-François-Xavier, Tel. 514-845-3646.* Not to be mistaken as your average French restaurant, their menu changes daily and prices are reasonable. Look for the speciality of the house – an amazing cold lobster salad with herb mayonnaise. Reservations suggested on weekends. Major credit cards.

Casa de Mateo ✪✪ *440 rue St-François-Xavier, Tel. 514-844-4154.* Like walking into a fiesta; this Mexican restaurant serves up a spectacular *pescado Veracruzano* (whole red snapper marinated and fried with vegetables), burritos, and enchiladas. *Mariachis* perform Fridays and Saturdays between 7 and 10 P.M. (reservations suggested on these nights). Major credit cards.

Chez Better ✪ *160 rue Notre-Dame, Tel. 514-861-2617.* The name definitely suits the spot. This unique blend of German cuisine and French decor offers a variety of knockwurst, sauerkraut, and over 100 kinds of beer. Major credit cards.

Chez Delmo ✪✪✪✪ *211 rue Notre-Dame, Tel. 514-849-4061.* Seafood has been the specialty here for decades. Enjoy the salmon and Dover sole amidst elegant decor. Reservations recommended. Major credit cards.

Claude Postel ✪✪✪ *443 rue St-Vincent, Tel. 514-875-5067.* Another 19th-century landmark building that has transformed from a morgue to a hotel to a restaurant; it tends to attract some celebrities. The menu changes daily, but you can always find caribou, venison, scallops, and salmon on the menu. Valet parking. Reservations recommended. Major credit cards.

Le Gargote ✪✪ *351 place d'Youville, Tel. 514-844-1428.* Located directly across the street from the history museum, this bustling French bistro is surprisingly *not* a tourist stop. Look for the duck sausage l'orange and veal kidney in a sauce *Diable*. They also offer meals for take-out if you are planning a picnic. MC and V only.

Gibbys ✪✪✪ *298 place d'Youville, Tel. 514-282-1837.* A steak and seafood house, this two-century-old establishment offers fresh bread straight out of their ovens to be served with their meats and fish, grilled to perfection. Dinner reservations required.

Le Jardin Nelson ✪ *407 place Jacques-Cartier, Tel. 514-861-5731.* You enter this restaurant, built in 1812, through a paved garden court and are seated in a beautifully shaded garden. Jazz combos (Fridays and Sundays) and classical chamber groups (Mondays through Thursdays) perform evenings. Phone reservations only. Major credit cards.

La Marée ✪✪-✪✪✪ *404 place Jacques-Cartier, Tel. 514-861-8126.* This French restaurant is elegantly decorated in the style of Louis XIII. A great location for a romantic candlelit dinner; offers the difficult choice of ordering the trout stuffed with salmon or the lobster mousse. Reservations required. Major credit cards.

Sawatdee ✪ *457 rue St-Pierre, Tel. 514-849-8854.* A reasonably priced restaurant where you can enjoy genuine Thai seasonings along with authentic Thai artwork. The luncheon buffet is very inexpensive. Major credit cards.

Stash ✪ *200 rue St-Paul ouest, Tel. 514-845-6611*. Since their recent move, the decor here now includes pews and wooden refractory tables rescued from an old convent. Large portions of great Polish delicacies such as roast wild boar, potato pancakes, and borscht. Reservations suggested on weekends. Major credit cards.

Plateau Mont-Royal

Au Coin Berbère ✪ *373 rue Duluth, Tel. 514-844-7405*. This quiet Algerian restaurant is a real treat for the couscous lover. The food is both excellent and reasonable. MC and V only.

Buona Notte ✪✪✪ *3518 St-Laurent, Tel. 514-848-0644*. The appeal here is the plates, painted by such celebrities as Danny DeVito and Winona Ryder, but the food is more than acceptable —risotto and pasta are the specialties. The atmosphere is definitely New York City's Soho-style. Reservations recommended. Major credit cards.

Ciné-Lumière ✪ *5163 St-Laurent, Tel. 514-495-1796*. This French-style bistro sets itself apart with 1920s films shown from 7 P.M. until midnight. As in other Montréal restaurants, there are many varieties of mussel dishes served (accompanied by *frites),* but you can also find rarer dishes such as ground bison and wild boar. Brunch Saturday and Sunday. Major credit cards.

Chez Schwartz Charcuterie Hébraïque de Montréal ✪ *3895 blvd. St-Laurent, Tel. 514-842-4813*. A nice, authentic Jewish deli that offers the best smoked meat in town and a lunch counter with cramped tables. If you're out late at night and hungry, it's open until 1 A.M. on weekdays and 2 A.M. on weekends. Cash only.

L'Express ✪✪ *3927 rue St-Denis, Tel. 514-845-5333*. This popular Paris-style bistro can be very loud on the weekends, because the food is so good and reasonable. Don't be misled by the low prices; the specialties include such gourmet delights as salmon with sorrel

and calves' liver with tarragon. It also has one of the best wine cellars in the city. Reservations necessary. Major credit cards.

Galaxie Diner ✪ *4801 rue St-Denis, Tel. 514-499-9711.* Originally a fifties diner in Newark, New Jersey, this establishment has been restored (complete with a jukebox full of American 50s music), and a terrace added on. The cuisine is a fun mixture of all-American fare and some Québécois favourites – such as *poutine* and sugar pie. Major credit cards.

Guy and Dodo Morali ✪✪✪ *Les Cours Mont-Royal, 1444 rue Metcalfe, Tel. 514-842-3636.* Nestled in the very chic shopping plaza Cours Mont-Royal, this classic French restaurant serves mostly seafood and a wonderful *agneau en croute* (lamb in pastry) with a special thyme sauce. Major credit cards.

Mazurka ✪ *64 rue Prince Arthur, Tel. 514-844-3539.* The cheapest Polish fare can be found here, although the service is rushed. Choose from pierogies, bigos, latkes, or stuffed cabbage for your mixed plate. Open until midnight. Major credit cards.

Milos ✪✪✪✪ *5357 av. du Parc, Tel. 514-272-3522.* This elegant Greek seafood house displays its selection of fresh octopus, squid, shrimp, crabs, and oysters on ice for patrons to select from — to be charcoal grilled and seasoned with parsley, capers, and lemon juice, creating a delicious meal. Other Greek specialties and lamb or veal chops available. Reservations required. Major credit cards.

Moishe's ✪✪✪ *3961 blvd. St-Laurent, Tel. 514-845-3509.* This is the place to get a great steak, specially aged for 21 days in coldrooms on the premises and charcoal-grilled to perfection. Also specializing in single-malt scotches. Dinner only. Major credit cards.

Pizzédélic ✪ *3509 blvd. St-Laurent, Tel. 514-282-6784.* This popular pizzeria has many imaginative toppings to choose from—

escargots to artichokes. This chain of pizzerias stays a step above the rest by using only fresh ingredients. Downtown location at 1329 Ste-Catherine. Open on weekends until 3 A.M. MC and V only.

Santropole ✪ *3990 rue St-Urbain, Tel. 514-842-3110.* Find a healthy salad or sandwich, or choose from 18 different kinds of milkshakes; enjoy your meal in a courtyard filled with flowers. Takeout menu available. Cash only.

Toqué! ✪✪✪✪ *3842 rue St-Denis, Tel. 514-499-2084.* Since "toqué" means "crazy" in French, you can expect a wild menu and preparation. Specialties include salmon *tournedos* and *foie gras*. Phone reservations needed one day in advance. Major credit cards.

Wilenskys ✪ *5567 rue Clark, Tel. 514-271-0247.* Wilensky's, a Montréal tradition since 1932, offers a great grilled sandwich, cheap prices, and absolutely nothing fancy. Cash only.

Witloof ✪✪✪✪ *3619 rue St-Denis, Tel. 514-281-0100.* The Belgian dishes are the best at this wonderful restaurant. A nice blend of both casual and elegant decor, their specialties include mussels with tents of *frites* appearing on the side and *waterzooi* (belgian stew). Reservations necessary. Major credit cards.

Ile Ste-Hélène

Hélène de Champlain ✪✪✪ *Ile Ste-Hélène (near Métro station), Tel. 514-395-2424.* The beautiful decor of the dining room, with fireplace and antiques, makes this restaurant a crowd-pleaser. Reservations necessary. Major credit cards.

Nuances ✪✪✪✪ *1 avenue du Casino, Tel. 514-392-2708.* You can find real French *haute cuisine* on top of this casino. Created only a year ago, the designers and chefs did a fabulous job with mahogany paneling and a unique menu—try the ostrich steak stuffed with mushrooms for a really different treat. Reservations necessary. Major credit cards.

ABOUT BERLITZ

In 1878 Professor Maximilian Berlitz had a revolutionary idea about making language learning accessible and enjoyable. One hundred and twenty years later these same principles are still successfully at work.

For language instruction, translation and interpretation services, cross-cultural training, study abroad programs, and an array of publishing products and additional services, visit any one of our more than 350 Berlitz Centers in over 40 countries.

Please consult your local telephone directory for the Berlitz Center nearest you or visit our web site at http://www.berlitz.com.

Helping the World Communicate